IMAGES
of America

JEWISH MILWAUKEE

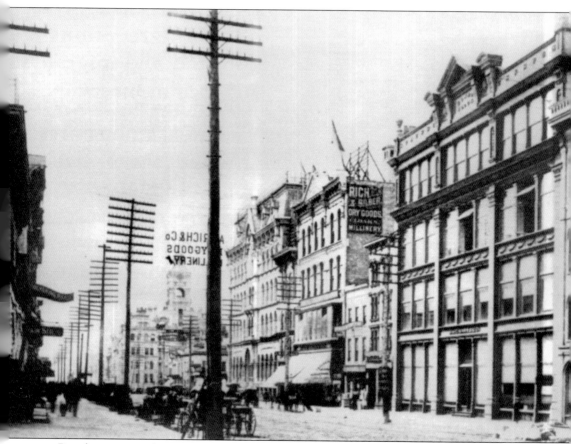

Broadway was a thriving center for business in Milwaukee's early days, with many Jewish-owned firms lining the streets. In addition, immigrants from Eastern Europe clustered on the near north side, west of the Milwaukee River. They were served by grocery stores, butchers, clothing shops, and other essential businesses. (Photograph courtesy of the Milwaukee Jewish Historical Society.)

IMAGES
of America

JEWISH MILWAUKEE

Martin Hintz

ARCADIA
PUBLISHING

Published by Arcadia Publishing
Charleston, South Carolina

Printed in the United States of America

Library of Congress Catalog Card Number: 2005932198

For all general information contact Arcadia Publishing at:
Telephone 843-853-2070
Fax 843-853-0044
E-mail sales@arcadiapublishing.com
For customer service and orders:
Toll-Free 1-888-313-2665

Visit us on the Internet at www.arcadiapublishing.com

On the cover: Delegates to the seventh annual Young Poale Zion Convention, August 31 to September 3, 1928, gathered in Milwaukee, meeting at the Jewish Folk Institute. (Photograph courtesy of Fannie Zilber Kesselman and the Milwaukee Jewish Historical Society.)

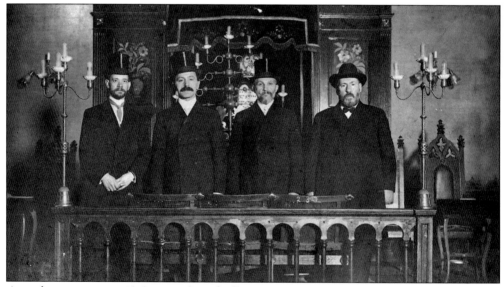

Attending services in 1912 was a formal affair at Congregation Beth Israel, 462 Fifth Street. Left to right were Rev. L. Cohen, cantor; I. J. Rosenberg, president; Rachmeal Cohen, vice president; and Jacob Rothstein, sexton. (Photograph courtesy of the Milwaukee Jewish Historical Society.)

CONTENTS

ACKNOWLEDGMENTS

Thanks to the expansive Milwaukee Jewish community for its support and encouragement while uncovering the marvelous photographs shown in this book. The stories accompanying the pictures were even more of a magnificent gift. The amount of material uncovered and shared will certainly fill another volume. This one book is not the final word on the who, what, where, why, and how of the broad sweep of Jewishness in the city.

Special appreciation is extended to Kathie Bernstein, director of the Milwaukee Jewish Historical Society, for her encouragement and support, and to Jay Hyland, society archivist, who spent hours combing through documents to confirm facts. A nod also goes to researcher Nick Michalski for his assistance and my wife Pam Percy for her valuable aid. In addition, the graciousness extended by the staff of the *Wisconsin Jewish Chronicle* was also much appreciated.

Another thanks is extended to Marianne Lubar, president of the Milwaukee Jewish Historical Society, for her insights and suggestions regarding Images of America: *Jewish Milwaukee*.

Above all, appreciation must be extended to all those individuals who eagerly searched for and then shared the perfect photographs of their families and friends.

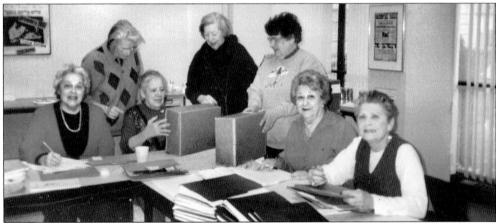

Volunteer archivists at the Milwaukee Jewish Historical Society in 2000 helped catalog many of the organization's voluminous files. Their hard work and perseverance have contributed to ensuring that the story of the city's Jewish people will be preserved. Pictured from left to right are: (seated, first row) Bernice Spivek, Clarice Borodkin, Rozann Rockstein, and Barbara Perchonok; (standing, second row) Beverly Schuminsky, Clarice Resnick, and Sharie Berliant. (Photograph courtesy of the Milwaukee Jewish Historical Society.)

INTRODUCTION

The Jewish community already had an impact in Wisconsin before the region became a state in 1848 and in the years prior to Milwaukee being incorporated as a city.

When treaties opened the frontier in the years after the Revolutionary War, traders, followed by land developers, laid the groundwork for subsequent waves of emigrants. One of the first known individuals of Jewish heritage in Wisconsin was Englishman Jacob Franks, who set up trading operations in Green Bay in 1804.

Wisconsin was an attractive destination for many reasons. Even before the railroads, Milwaukee's excellent harbor allowed easy access to America's interior and readily made the city a vibrant commercial center. Jewish émigrés found a receptive home, one that was open to their enthusiasm, creativity, and energy.

Milwaukee's general population grew from 2,700 in 1842, to 9,655 in 1846. In 1850, residents numbered 20,061. Within that mix was a growing representation of Jewish families. Among the arrivals was Emanuel Myer, who came in 1844 with his brothers Gabriel, Samuel, and William. Moses Weil, Isaac Neustadtl, and Solomon Adler were other early Jewish personalities. Bernard Heller of Citow, Bohemia, arrived in 1849. He and his family had sailed for six weeks across the Atlantic, followed by another six weeks trekking inland via the Erie Canal and the Great Lakes. Native Americans lived in tents on a hill behind the Hellers' modest home, built for $25 on Sixth and Chestnut Streets.

By 1850, 70 Jewish families lived in the city. In 1852, there were about 100, and by 1856, it was estimated that there were more than 200 Jewish families. Around 1895, Milwaukee's Jewish population numbered some 7,000, making up around three percent of the city's inhabitants.

These numbers grew to about 34,000 Jews living in Wisconsin in 1930. That number included 30,000 in Milwaukee, 1,000 each in Madison and Sheboygan, and 2,000 scattered throughout the rest of the state. Today, the estimate hovers around 28,500, with most living in Wisconsin's larger communities.

At first, the Jewish Milwaukee presence was largely the result of a massive German influx around the American Civil War. Out of 47 Jewish arrivals between 1844 and 1855, 24 came from Germany, 20 from Bohemia, Hungary, and Austria, with only two from France and one from England. As early as 1845, more than a third of the city was of German heritage. From the 1840s to pre-World War I, Wisconsin was the most German of all the United States, and Milwaukee was the most German city outside Europe. In the late 19th century, many Eastern European Jews arrived and, adding to the marvelous mix several generations later, another wave of Russian Jews swept into the city in the 1980s.

Capitaling on all these hardy roots, Milwaukee's current Jewish community continues to draw on a fabulously rich heritage—whether the arrivals were by chance or choice—while living in the present and looking forward to whatever comes next. It is certain that all challenges will be met. That's the way it's always been in Jewish Milwaukee.

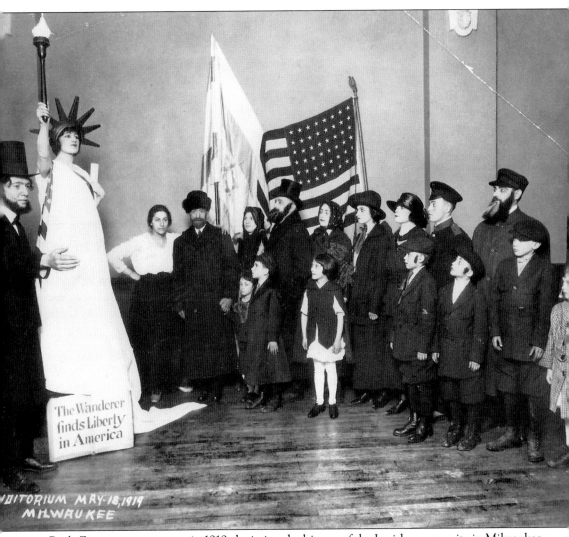

The Wanderer
finds Liberty
in America

UDITORIUM MAY-18,1919
MILWAUKEE

Poale Zion put on a pageant in 1919, depicting the history of the Jewish community in Milwaukee up to that time. The woman in the role of Liberty is thought to be Goldie Mabovitch Meyerson, who became famous as Golda Meir, prime minister of Israel. (Photograph courtesy of the Wisconsin Historical Society.)

One

THE EARLY YEARS

The Jewish community was swept up in the mass migration from Europe in the mid- to late 19th century and early 20th century, with politics, religious repression, and economic factors driving the exodus. Many Jews were lured to Milwaukee, seeing opportunity because jobs were plentiful and there was a strong ethnic influence akin to what they had known in the Old Country . . . without the pogroms. They came with religious items carefully tucked amid bedding, clothing, and other personal items, praying on the docks of Europe until their passage was cleared on the next outbound vessel.

Upon their arrival in the New World, some Jews began their lives as peddlers or rag pickers, by collecting metal and recyclables. Many saved enough money to open a store. As they became schooled in the ways of America, they bought and started other businesses. As they became established, the first arrivals were ready, available, and willing to help the next wave of newcomers, which peaked between 1880 and 1924.

Well-to-do Jews in New York founded the Industrial Removal Office in 1901, to encourage immigrants to move to other parts of the United States, such as Milwaukee. Milwaukee's Jewish community enlisted in this cause and immediately helped bring almost 800 newcomers to the city from the East Coast. Jobs were found and children placed in schools as the cycle of assimilation continued. Another large group of Jews fled Europe in the dark days prior to World War II.

Keeping in touch with their community, the Jewish immigrants were avid readers of publications in German, English, and Yiddish. In the 1880s, Rabbi Isaac Moses of Congregation B'ne Jeshurun was one of the publishers of *Der Zeitgest*, a biweekly German newspaper. The Yiddish *Milwauker Wochenblat*, established by Isadore Horwitz in 1914, also had an English edition. Victor Berger published the *Leader* to promote his Socialist Party ideals. Nathan Gould and Irving Rhodes started the weekly *Wisconsin Jewish Chronicle* in 1921. The paper is still being published under the aegis of the Milwaukee Jewish Federation.

The Abraham Lincoln House on Ninth Street was the hub of Jewish life, around the time of World War I, as a meeting place for immigrant and native young people. The facility hosted a cooking school, literary and theater clubs, sewing classes, and other activities. Among its first directors were Stella B. Rosenbaum (1916–1918) and Helena Stern (1918–1922).

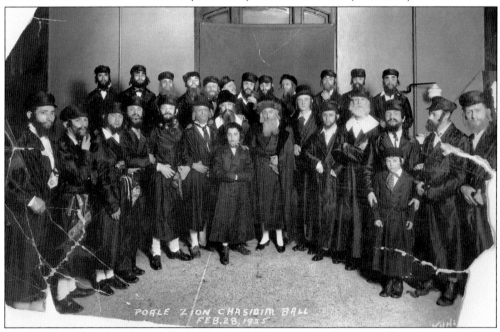

The Poale Zion Chasidim Ball, held on February 28, 1925, attracted many participants who dressed in Old World costumes. (Photograph courtesy of Kuhli Studios and the Jewish Community Center.)

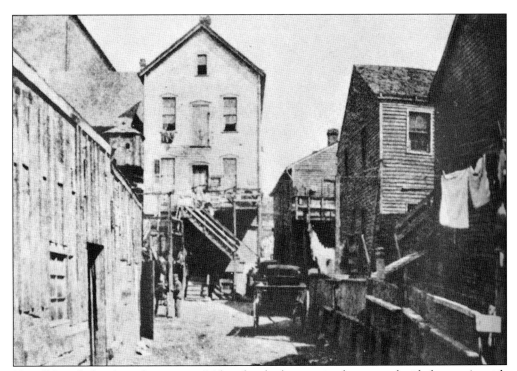

Not all Jewish families who came to Milwaukee had expansive homes and wide lawns. As with many newcomers to the city, they lived in crowded houses backed by narrow alleys. Washing hung outside and work wagons were parked by the back door for easy access.

One of the largest clothing manufacturers in Milwaukee during the 19th century was David Adler & Sons, founded by Adler's older brother, Solomon, who had emigrated from Bavaria in 1848. David Adler came to the United States in 1846 and on to Milwaukee in 1851 or 1852. He opened a small clothing store on East Water Street and eventually bought out his brother's business and put his own name on the firm. Adler was very active in many Jewish organizations. (Photographs courtesy of the Milwaukee Jewish Historical Society.)

At age 21, Lewis Ganter cut a dashing figure in his wedding suit when he was married in 1904. Ganter changed his name to Louis Goldberg when he came to Milwaukee, taking the surname of his Uncle Harold who already lived in the city. Originally a picture framer who had emigrated to England from Lithuania, he became a fruit peddler, working out of Milwaukee's Commission Row before opening his own fruit business on Fifth Street. Ganter could fluently speak Russian, Polish, English, and several other languages in the course of his job. Ganter's father, Abraham Joseph Ganter, was a blacksmith.

Dora Padway Goldberg held her first-born son, Isadore "I. E." Eugene, prior to moving to Milwaukee from her family home in Middlesbrough, York, England. Daughter of grocer Morris Padway, she married Lewis Ganter in England on May 24, 1904. The couple had five other boys (Alfred Gerald, Max Solomon, Jacob, Sydney Bernard, and Albert Joseph) and two girls (Jeanette and Beatrice). (Photographs courtesy of the Chudnow family.)

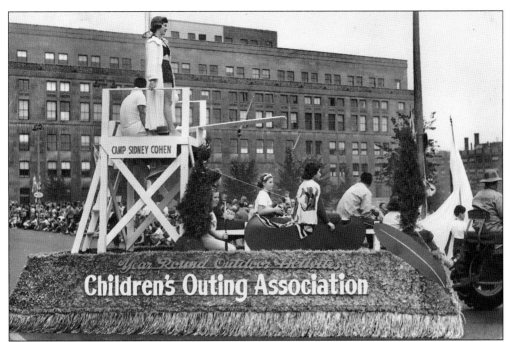

Riding a magnificently decorated float, youngsters from the Children's Outing Association participated in a parade in the mid-20th century. In 1896, Lizzie Kander founded the Keep Klean Mission, sponsoring activities for area youngsters. In 1906, Kander and other women established the Personal Relief Society, which took kids on outdoor adventures. In 1909, the Fresh Air Camp was established near Thiensville, and the Children's Outing Society became known as the Children's Outing Association in 1930. Sophie Cohen donated a gift in 1928 for the establishment of Camp Sidney Cohen. Camp Helen Brachman was established in 1990. (Photograph courtesy of the Milwaukee Jewish Historical Society.)

Members of the Lapham Park Drama Club rehearsed for a play in the early 1930s. Among the group was Al (Patashnick) Padek in the upper right. The club was one of many such social groups which attracted young people from the Jewish community, eager to mix and mingle with their friends. (Photograph courtesy of Richard Chudnow.)

Russian-born Ben Safer sailed alone to the United States at age 16, from the port of La Havre, landing in Baltimore and making his way to Milwaukee where he had a cousin. In order to earn a living in Milwaukee, he became a peddler and eventually went into car sales. Through a *shadchen*, a professional marriage broker, Safer met and married Rose Raffelson in 1923. She had come to Sheboygan with her family from Kamin, Russia. (Photograph courtesy of Tybie Taglin.)

In 1922, Joseph Taglicht, a native of a small town near Bratislava, Slovakia, came to Milwaukee where he had relatives. Taglicht became a butcher, with a shop at Seventh and Lloyd Streets. In 1922, he met Sylvia Borkin who had come to Milwaukee in the early 1920s from Minsk. Taglicht and Borkin were married in 1923 and the family name evolved into "Taglin." (Photograph courtesy of Max Taglin.)

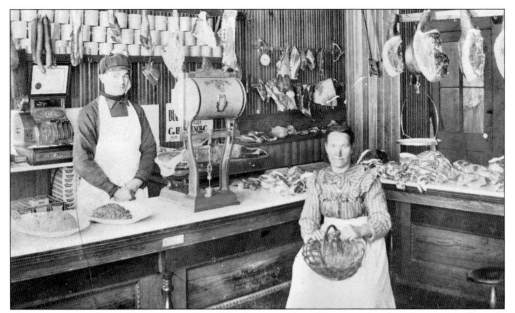

There are several notable meat packing families in Milwaukee. Bernhard Peck was a well-to-do cattle buyer in Bavaria, but heard that business was good in Milwaukee. Subsequently, he packed up his family in 1891, and came to Milwaukee where he built a slaughter house. Peck died in 1923 but the firm, which eventually had 800 employees, remained in the family until it became a division of the Sara Lee Meat Group in the mid-1980s. The photograph shows the Alfred Peck Butcher Shop on Eighteenth Street and North Avenue.

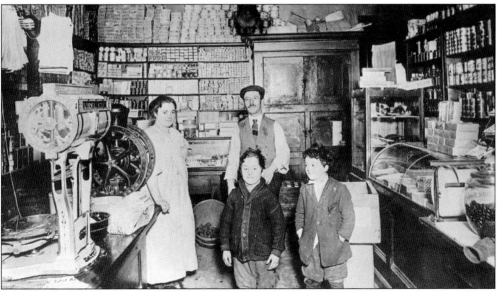

The Trushinsky family was typical of the small business owner in Milwaukee prior to World War I. Max Trushinsky emigrated to Milwaukee in 1908, first launching a milk delivery route and, then opening a dairy store. He soon purchased a grocery, which he ran with his wife, Mary. Sam, one of the Trushinsky sons, eventually opened his own food outlet and belonged to the Jewish Grocers' Organization. (Photographs courtesy of the Milwaukee Jewish Historical Society.)

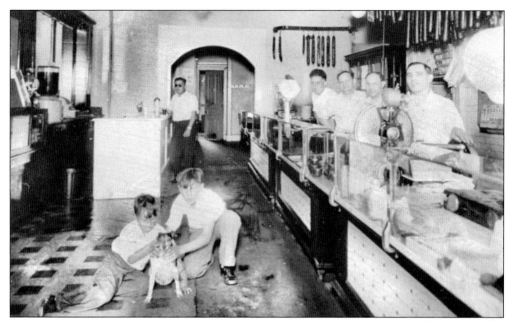

The local delicatessen was often the hub of a neighborhood, where everyone felt comfortable, especially if a recent émigré. Notable eateries included Kurman's, Plotkin's and others located in the vicinity of Walnut, Vliet, Center, Burleigh Streets, and North Avenue. Among those working behind the counter at the Guten & Cohens Deli, 714 West Walnut Street, in June 1931, were (from left to right) Carl Guten, Ruben Cohen, Meyer Guten, and Erv Miller. The others are not identified.

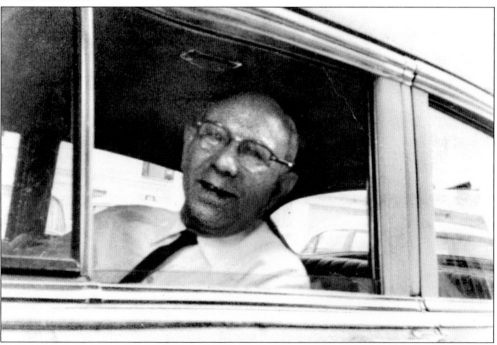

Ruben Cohen, owner of Cohen's Deli, going for a drive in 1945. (Photographs courtesy of the Milwaukee Jewish Historical Society.)

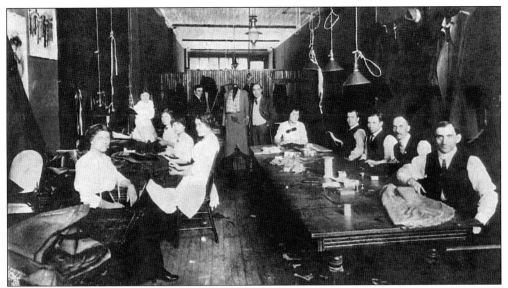

Tailor shops were a big business in Milwaukee in the early 20th century. Many were small Jewish subcontractors who in turn sold their products to larger companies. The Milwaukee clothing industry, however, was often the subject of labor unrest in the 1920s, with strikes and lockouts common. The hosiery and knitting industry was led by Morris Miller (1847–1931), Max Karger (1871–1959), and his brother David (1866–1939).

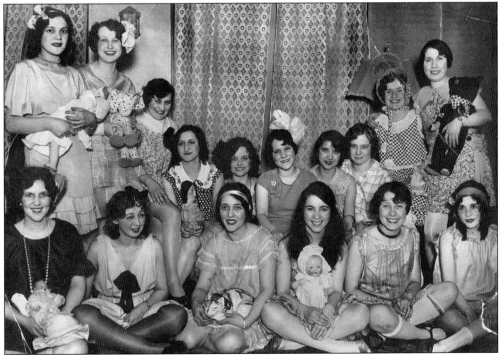

"Baby doll" parties were the rage among girl friends during the 1920s and 1930s, providing a golden opportunity to talk about guys and "dolls." (Photographs courtesy of the Milwaukee Jewish Historical Society.)

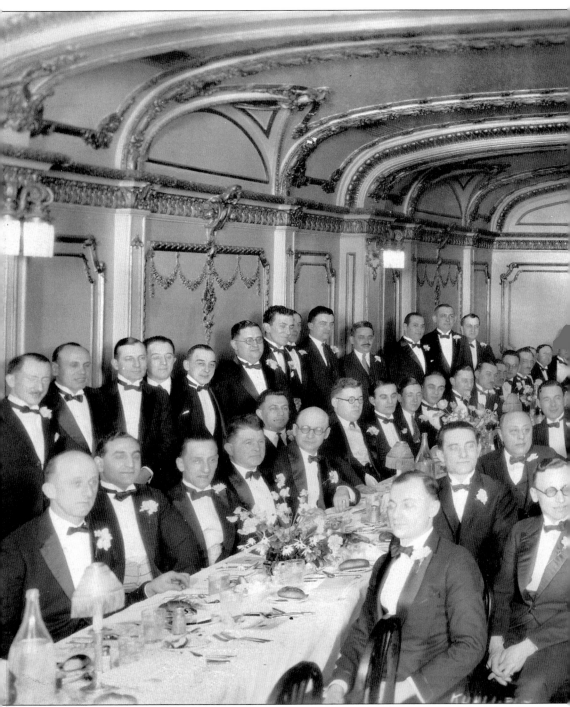

The fourth annual Sholom Aleichem Circle met for a dinner and program on April 5, 1924, in the Wisconsin Hotel. On its board of governors at the time were A. P. Rosenberg, J. L. Bitker, Morris Stern, N. B. Goldstein, B. E. Nickoll, Robert A. Hess, Michael Levin, Harry Levine, and Samuel Blink. The name in Hebrew means "peace be unto thee." The group met informally each noon to "exchange views and opinions." In the 1920s, it had more than 400 members, most

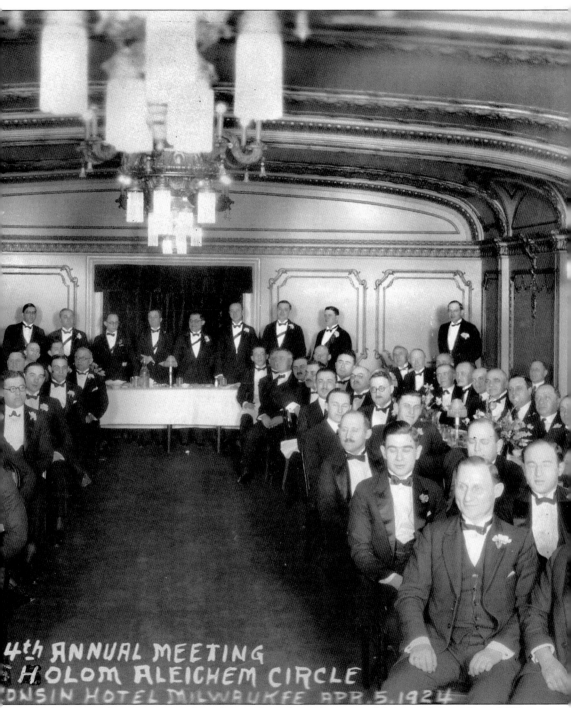

4th ANNUAL MEETING
SHOLOM ALEICHEM CIRCLE
WISCONSIN HOTEL MILWAUKEE APR 5 1924

of whom were businessmen and professionals such as doctors and lawyers. Mayor Daniel W. Hoan said he "found these men to be of the highest type, progressive in spirit, firm in integrity and aggressive in their accomplishments." (Photograph courtesy of the Milwaukee Jewish Historical Society.)

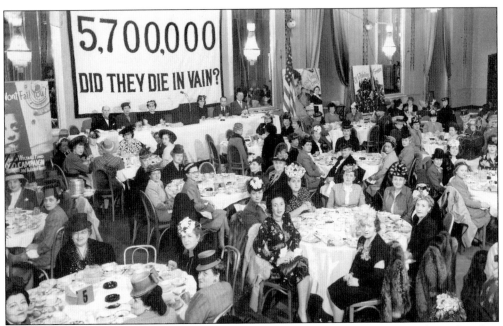

Hats made a distinct fashion statement at one of the initial luncheon rallies of the Milwaukee Jewish Welfare Fund, held on April 25, 1947. A banner marking the number of dead in the Holocaust, however, was a grim reminder of the cause at hand. In the lower photograph, Sol Kahn (standing) gave an initial gifts report at a meeting of welfare fund planners in 1949. (Photographs courtesy of the Milwaukee Jewish Historical Society.)

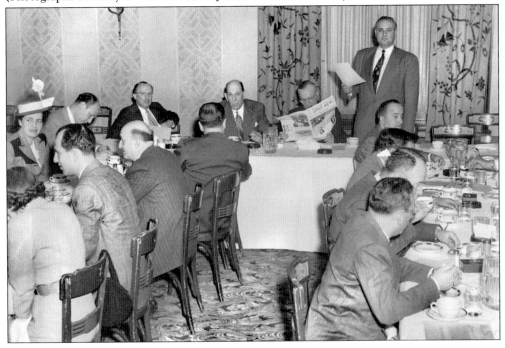

ANNUAL MEETING
Milwaukee Jewish Welfare Fund, Inc.

Guest Speaker

MOSHE SHERTOK

Chief of Political Department of the Jewish Agency

The probable Foreign Secretary of the new Jewish State who has just arrived from Palestine will describe present conditions there and will tell of the 1948 needs of the United Jewish Appeal for $250,000,000. This is a rare privilege and your opportunity to see and hear this great leader of world Jewry.

Sunday, February 1 at 8 p. m.

Crystal Ballroom **Hotel Schroeder**

Every member of the Welfare Fund is invited to be present to participate in the business of the Annual Meeting.

Famous guests were often invited to Milwaukee to help kick-off fund drives for various causes. In 1948, Moshe Shertok, chief of the political department of the Jewish Agency, was a speaker at a Jewish Welfare Fund program. (Photograph courtesy of the Milwaukee Jewish Historical Society.)

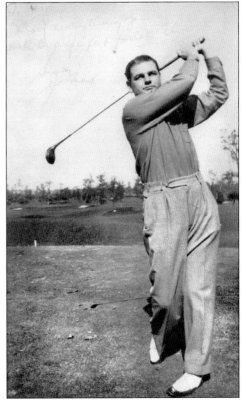

Demonstrating his form, the redoubtable Joe Frank was the renowned golf pro at Brynwood Country Club for many years. He was instrumental in placing the club's top players on the tournament circuit. Frank provided them with excellent advice and encouragement as they honed their skills and went on to capture titles in many divisions over the years. (Photograph courtesy of Brynwood Country Club.)

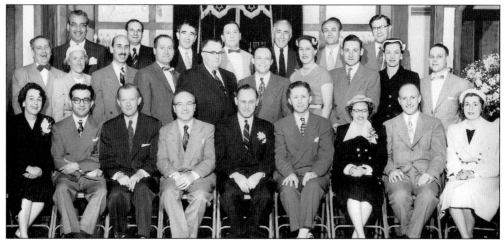

The first board for Congregation Shalom for 1951 to 1952 included, from left to right: (first row) Mrs. Milton Hoffman, Daniel Howard, Arthur Levin, David R. Pasch, Rabbi Harry Pastor, David Goodman, Mrs. Jacob Beck, Henry Arnold, and Mrs. Delbert Wile; (second row) Aaron Tilton, Mrs. Arthur Goldberg, Isador Abrams, Alexander Lakes, Jacob Beck, Harold Willenson, Mrs. Harry Pivar, Donald Hamilton, Mrs. Mathew Horwitz, and Edward Zien; (third row) Dr. Donald Ausman, Dr. E. J. Emanuel, Dave Miller, Herman Williams, Herman Eisenberg, Edward Meldman, and Jerry Callner. Not present for the photograph were Robert Gill, Sam Langer, Judd Post, Dr. Leonard Shapiro, Dr. Milton Smuckler, Paul Spector, and Harold Winston. (Photograph courtesy of Congregation Shalom.)

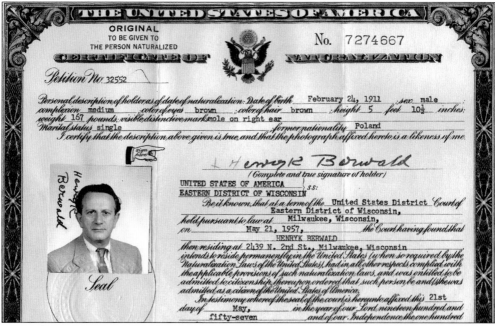

Born February 24, 1911, in Krakow, Poland, Henryk Berwald was made a United States citizen on May 21, 1957. A furrier, Berwald fled Poland in 1944, and made his way to the British-controlled zone of Germany. In the summer of 1950, Berwald arrived in Milwaukee where his sister, Anna, lived. He became a tailor at Walters Tailor Shop, retiring in 1974. He died in 1978. (Photograph courtesy of the Milwaukee Jewish Historical Society.)

Two

ALL IN THE FAMILIES

Family life, with all its nuances, is extremely important to Milwaukee's Jewish community. Birthday parties, bar and bat mitzvahs, weddings, anniversaries, and funerals add to the wide spectrum of what constitutes life, from birth to beyond. There seldom needs to be any more of a reason for a social visit other than the need to get together. The process of staying in touch keeps the web of Jewishness strong and vibrant. Within the enfolding arms of the extended family, all is always well.

Many wonderful photographs and ancillary materials donated by the community fill the archives of the Milwaukee Jewish Historical Society. Portraits of the past include that of Ella Pick Rockstein, born in Manitowoc, Wisconsin, but whose parents came from Germany. Her husband, John, was born in Kiev, Russia, and started a men's clothing store in Merrill, Wisconsin. The couple was married on November 21, 1911, when he was 27 and she was 23. After living in Michigan for a time, the family moved to Milwaukee during the Great Depression after John Rockstein suffered a stroke. Their daughter, Rozann Rockstein, became the first paid worker at the Milwaukee Jewish Welfare Fund (JWF), working under Nathan Stein who was the organization's first president. Rozann remained at the JWF for 42 years. The group eventually evolved into the Milwaukee Jewish Federation.

Other stories, as in real life, were not so happy. A newspaper sidelight in 1930, told of Sonia Mason, the 19-year-old daughter of Legia Magarschak, the Anshai Lebowitz *shammas* (janitor) who was publicly disowned by her father in a municipal court trial. Young Mason was called a "communist leader" by the *Milwaukee Journal*, after being arrested for handing out leaflets prior to the city's Haymarket Square labor disturbances that spring. The elder Magarschak had come to Milwaukee following the Bolshevik Revolution in Russia. He sent his daughter to West Division High School "to learn the language, manners, and customs of the new country." "Instead," the newspaper said, she became "a radical and broke with her family."

Over all the years, however, Milwaukee's extended Jewish "family," continues to move resolutely together towards the future. Of course, as in any family, there are tears. But more often there are smiles.

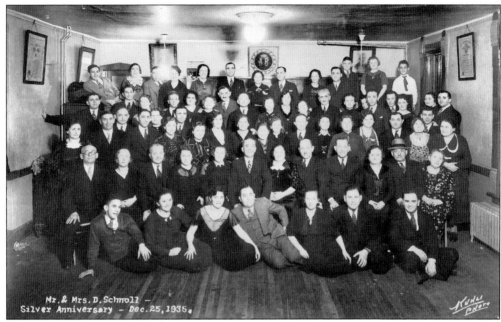

Numerous family and friends gathered around to celebrate the silver anniversary of Mr. and Mrs. David Schnoll on December 25, 1935. (Photograph by Kuhli Studios, courtesy of the Milwaukee Jewish Historical Society.)

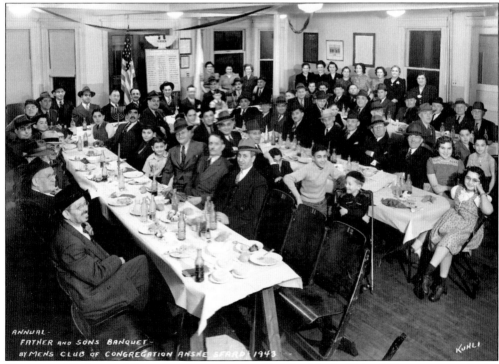

The annual Father and Sons Banquet, sponsored by the Men's Club of Congregation Anshe Sfard, attracted a roomful of parents and children in 1943. (Photograph courtesy of the Milwaukee Jewish Historical Society.)

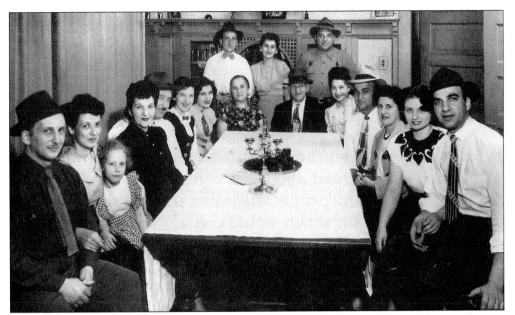

The Chudnow family celebrated seder on April 24, 1948. Pictured from left to right are: (standing) Joseph and Marian Chudnow and Sam Chudnow; (seated) Abe Chudnow, his wife, Anita, and daughter, Lois, Annabelle (Chudnow) Schulner and her husband, Harry Schulner, Sandra Schulner, Beverly Schulner, Sarah Chudnow, Max Chudnow, Ruth Chudnow, Ben Chudnow and his wife, Beatrice, and Eileen and Erv Chudnow. (Photograph courtesy of Dick Chudnow and the Milwaukee Jewish Historical Society.)

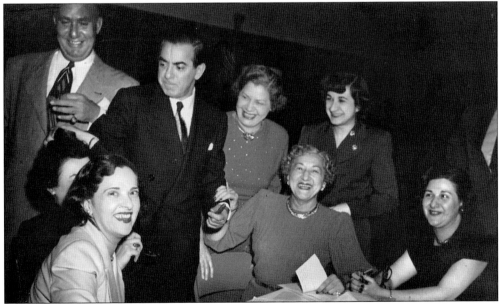

Surrounded by fans, actor and musician Eddie (Banjo Eyes) Cantor visited Milwaukee in 1949 to help with the Milwaukee Jewish Welfare Fund Campaign. In the 1940s, Cantor's NBC Radio show, *Time to Smile*, was one of the most popular family entertainment shows on air. He regularly toured the country, supporting various Jewish causes and other charities. (Photograph courtesy of the Milwaukee Jewish Historical Society.)

Herbert Polacheck, born June 24, 1909, and his sister Jane Polacheck Wolfe, born November 22, 1914, were a handsome pair in this youthful portrait. At the time, their father, Rudy, operated a clothing store and tailor shop downtown. Young Herb worked for his father before moving over to Milwaukee's Reliable Knitting in its sales department and eventually heading the firm. He married Isabelle Rosenberg, the daughter of Armin Rosenberg, one of Reliable's founders. Jane married Leonard Wolfe, a Milwaukee insurance executive.

Barbara Polacheck Blutstein and her husband Morty mailed this photograph as their first holiday card in 1962. The couple met in New York City and were married at Milwaukee's Congregation Sinai on September 23, 1961. They returned to Milwaukee when Barbara's father, Herb Polacheck, offered Morty a job at Reliable Knitting. Morty eventually became an executive vice president of the company. Barbara is an art consultant with the Katie Gingrass Gallery. (Photographs courtesy of Barbara Blutstein.)

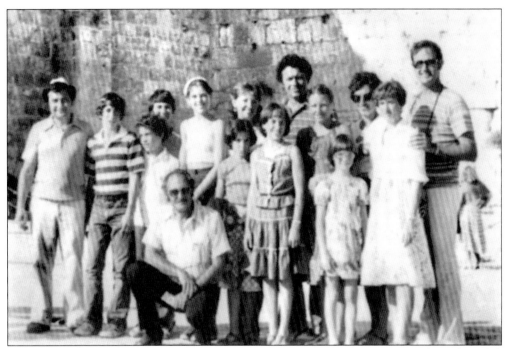

Members of three Milwaukee families visited Israel in August, 1977. Among them, from left to right, were: (first row) Ricky Teper, Lisa Lieberman, Leslie Stein, Dena Lieberman, Leigh Stein, and Debbie Stein; (second row) Bob Teper, Jim Teper, Marilyn Teper, Jan Lieberman, Nancy Lieberman, Stan Lieberman, Louise Stein, and Jerry Stein. Kneeling in front was guide Ellie Belkin.

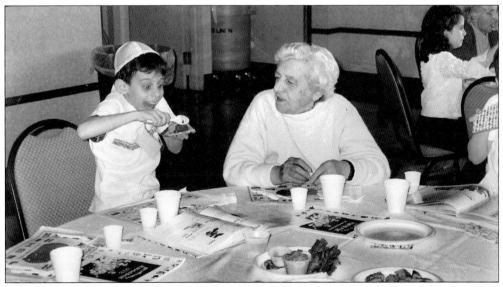

Jewish Community Center (JCC) Senior Center member Muca Bordetsky watched as Sam Melton, a third grader at the Milwaukee Jewish Day School, piled horseradish on a piece of matzah in the Rubenstein Pavilion. The "intergenerational seder" encouraged youngsters to relate with elders in the Jewish community. (Photographs courtesy of the *Wisconsin Jewish Chronicle*.)

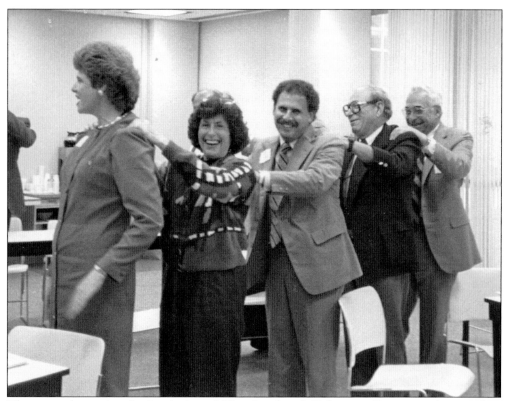

There was always time for fun during a Milwaukee Jewish Federation Campaign. A conga line at this 1980s worker training session included, from left to right, Anita Jacobs of United Jewish Appeal, Muriel Becker, Bert Bilsky, Bill Orenstein, and Gerry Minkoff. (Photograph courtesy of the Milwaukee Jewish Historical Society.)

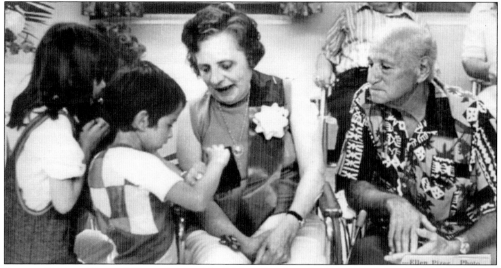

Sara and Milton Geisenfeld, residents of the Milwaukee Jewish Convalescent Center, enjoyed Mrs. Geisenfeld's birthday along with her grandchildren Mark and Elizabeth Wiletsky. (Photograph by Ellen Pizer, courtesy of the *Wisconsin Jewish Chronicle*.)

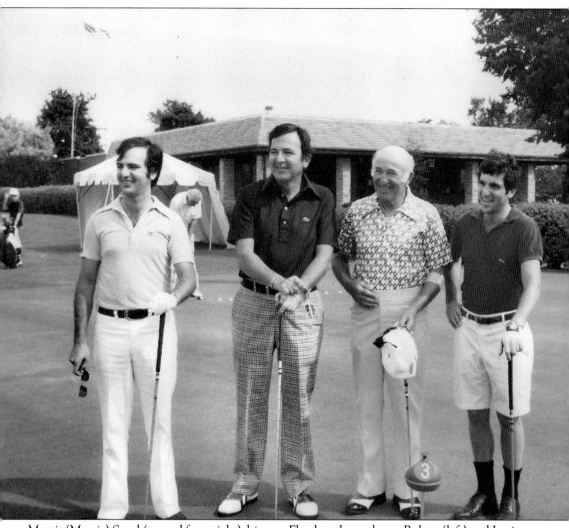

Morris (Morrie) Segel (second from right), his son, Floyd, and grandsons, Robert (left) and Justin (right) took a break from an early golf match at the Brynwood County Club in the 1970s. The elder Segel was born in 1901 in Eastern Europe. His father, Nathan Segel, came to Sheboygan to work and returned to Europe for his family. They came back to Sheboygan around 1910, where Morrie was employed in a kosher butcher shop. He purchased a Model-T Ford when he was 16, for transporting veal calves. After high school, Morrie moved with his family to Milwaukee where he opened a small grocery store and married Blanche Grimson in 1924. About 1930, Morrie partnered with Sam Roitblatt to form the Ideal Packing Company. He then joined with his brother Jack and Phil Pinkus in organizing the Wisconsin Packing Company. After service in World War II, his oldest son, Floyd, became a partner. The firm was eventually known as Emmpak Foods, created by the 1996 merger of Emmber Foods and Wis-Pak Foods. Floyd's son, Justin, became the company's CEO after Floyd retired in 1990. The firm grew to three packing plants employing 1,800 persons. In 2001, Emmpak was sold to Cargill. (Photograph courtesy of Floyd Segel.)

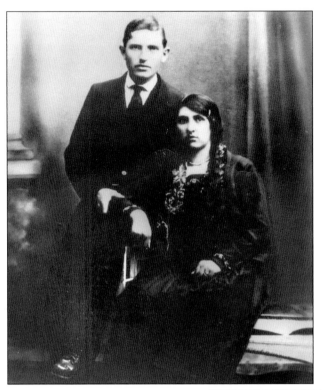

David Gendelman and his wife, Fanny, came to Milwaukee from Russia in the 1920s, and he formed Century Steel, which evolved into Century Hardware. After World War II, his son Max joined the distribution company and became president in the 1970s. Esther, the Gendelman's daughter, married Jack Spector, who also worked there as vice president. In addition, Gendelman's youngest son, Sheldon, worked at Century, eventually becoming president of Hardlines Marketing and of Dealer Mart, two other divisions of the firm.

Doran (Danni) Gendelman and Sheldon (Shel) Gendelman were a dashing couple in 1952 at a University of Wisconsin fraternity party. After graduating in 1954, Danni and Shel moved to Milwaukee. In 1970, after her three children were in school, Danni worked in an office furnishing division of Century Hardware and, some years later, purchased it. Her firm, InterPlan, was soon listed as the 13th-largest woman-owned enterprise in Wisconsin and ranked in the top 500 of women's businesses in the country. (Photographs courtesy of Danni and Sheldon Gendelman.)

Judge Jeffrey A. Wagner and his family gathered for a photograph. In the rear, from left, are son-in-law Tim Strauss, president of Strauss Veal & Lamb, daughter Danielle Wagner Strauss and his wife, Dyan, a district reading specialist at Maple Dale-Indian Hill School. He is seated in front with his son, Benjamin, an attorney with Habush Habush and Rottier, S.C. Wagner was first elected as a municipal judge in 1983 and elected a circuit court judge in 1988, serving in Branch 38. His grandfathers emigrated from Russia. (Photograph courtesy of Judge Jeffrey A. Wagner.)

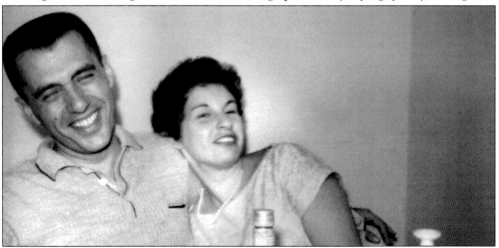

Eve Steuer and Elliot Lipchik relaxed in Basil, Switzerland, where he was attending medical school a year after their marriage. After the Nazis Anschluss in her native Austria, Eve and her mother sailed to New York on one of the last liners to leave Italy before World War II. Elliot's family came to America from Poland in 1920. The two met in college, coming to Milwaukee in 1976. Elliot worked at Mount Sinai Hospital before joining the Medical College of Wisconsin. Following his retirement in 1995, he became a widely published poet. Eve is a specialist in family therapy and cofounder of ICF Consultants, Inc. (Photograph courtesy of Eve and Elliott Lipchik.)

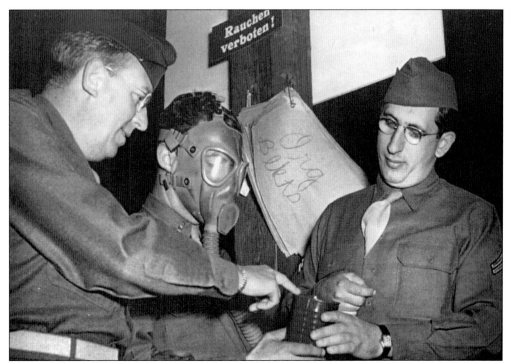

During World War II, Technical Sergeant Leo Kissel (right) edited the *Real McCoy*, the newspaper at Camp McCoy, Wisconsin. After the war, he rejoined the *Milwaukee Sentinel* and remained there until his retirement in 1980. A past president of the Milwaukee Press Club, Kissel was also inducted into the organization's hall of fame. (Photograph courtesy of the Kissel family and the Milwaukee Jewish Historical Society.)

Milwaukee native Howard Kissel has been the chief drama critic for the *New York Daily News* since 1986 and also writes the biweekly "Cultural Tourist" column. In addition, he reviews art and classical music and has written several books. Kissel has been chairman of both the New York Film Critics Circle and the New York Drama Critics Circle. (Photograph courtesy of Ruth Kissel.)

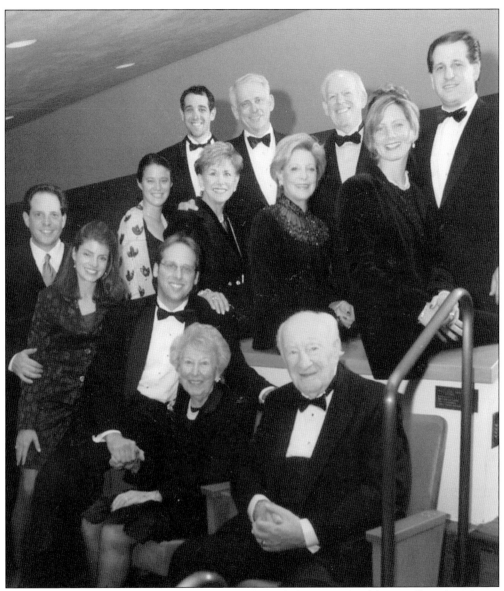

The Ben Marcus family and friends attended the rededication of Uihlein Hall at the Marcus Center for the Performing Arts in 1997. Pictured from right to left are: (first row) Ben Marcus, Ceil Marcus, Larry Kite, Melina Marcus, and David Marcus; (second row) Linda Marcus, Joan Marcus, Diane Marcus Gershowitz, and Dana ?; (third row) Greg Marcus, Steve Marcus, Hal Gershowitz, and Andy Marcus. In 1935, Ben Marcus founded the Marcus Corporation, which includes movie theaters, hotels, resorts, and restaurants. Born in Poland, Marcus helped spearhead fundraising drives to restore the Statue of Liberty and Ellis Island. In 1996, after a $5 million donation from the Marcus Corporation for the renovation of the Performing Arts Center, the complex was renamed the "Milwaukee County Ben and Ceil Marcus Center for the Performing Arts." Their son Stephen succeeded his father as board chairman in 1991. He has been active in many volunteer projects, and in 2005 became chairman of the Greater Milwaukee Foundation board. (Photograph courtesy of the Marcus Center for the Performing Arts.)

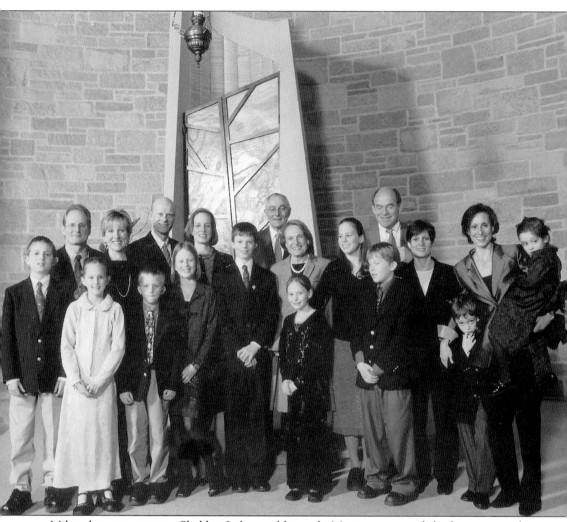

Milwaukee entrepreneur Sheldon Lubar and his wife, Marianne, met while they were students at the University of Wisconsin in the 1950s. He was a waiter at the dormitory where Marianne lived. The couple married in 1952, during Lubar's third year of law school and then moved to Milwaukee after graduation. They have four children, all active in Jewish community affairs. In the photograph, their family had gathered for the bar mitzvah of grandson Simen Solvang at Congregation Sinai. After her family was raised, Marianne became a potter and is an active community volunteer. She is also chair of the Milwaukee Jewish Historical Society. Lubar started with the Marine National Exchange Bank in 1953 and worked on venture capital and mortgage banking projects. Among his many civic roles, Lubar has been president of the UW Board of Regents and serves on many profit and non-profit boards. In 2005, the Lubars were honored by the Greater Milwaukee Foundation for their volunteer work. (Photograph courtesy of Marianne and Sheldon Lubar.)

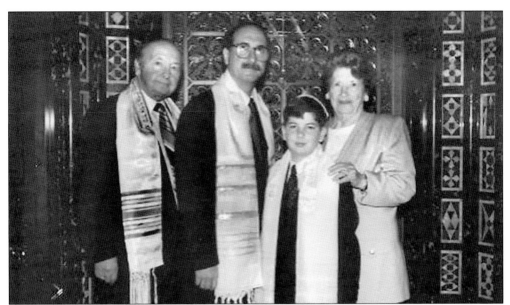

Drew Chapman was joined by his father Richard and grandparents Lou and Harriet Chapman at his bar mitzvah in 1995. After graduating with a bechelor's degree in Russian language, Drew went to Siberia where he worked on youth entrepreneurship projects and then went on to graduate school. His grandfather, *Milwaukee Sentinel* reporter Lou Chapman, won the Wisconsin Sports Writer of the Year award five times and was inducted into the Milwaukee Press Club's Media Hall of Fame in 1999. Drew's father, film writer Richard Chapman, coproduced the Emmy-nominated 2002 television movie *Live From Baghdad*. (Photograph courtesy of Richard Chapman.)

Cindy Levy and her daughter Sharon examined a gift from the gift shop located in the Israel Museum, created at the Children's Lubavitch Living and Learning Center in 2001. They were commemorating Jerusalem Day and a belated Mother's Day. (Photograph courtesy of the *Wisconsin Jewish Chronicle*.)

Part of Milwaukee Jewry's 1994 sesquicentennial celebration, an event held at the Milwaukee Public Museum, featured a mock turn-of-the-century-style Jewish wedding ceremony officiated by Rabbi Herbert Panitch. Dr. Michael and Debbie Herz Mazius put on 19th-century attire for the ceremony, which celebrated their own 10th wedding anniversary. The bride's parents, Thomas and Maxine Herz, stood at the canopy with Ruth and Dr. Jerome Traxler. (Photograph by Andrew Muchin, courtesy of the *Wisconsin Jewish Chronicle*.)

The first Jewish baby of 1999 was Julia Ross, born January 9, to Stephanie Bernstein Wagner. Milwaukee's first Jewish child was Emma Herbst, born September 16, 1849. (Photograph courtesy of the *Wisconsin Jewish Chronicle*.)

Three

IMPORTANCE
OF COMMUNITY

Integral to the success of Milwaukee's cohesive Jewish community are the twin values of working together and aiding others. Building on the three principal pillars of rescue, relief, and renewal, these tenets have always been how Jews look after Jews. To aid the growing numbers of émigrés in the 19th century, Jewish federations, such as the one in Milwaukee that started in 1902, were organized around the country.

Milwaukee's first social service agency, the Hebrew Relief Society, is known now as Jewish Family Services. In 1900, the Jewish Mission merged with the Council of Jewish Women and the Sisterhood of Personal Service to form the Milwaukee Jewish Settlement. The Settlement rented a house on Fifth Street and moved to a larger one in 1904. In 1911, the Settlement took over the newly built Abraham Lincoln House on Ninth and Vine Streets, acting as forerunner to today's Jewish Community Center, so renamed in 1931. Mount Sinai Hospital was organized in 1902 and the Hebrew Free School for Jewish Education was launched in 1904. The Hebrew Sheltering House opened in 1909. To support these and other agencies, the Federated Jewish Charities (FJC) led the financial campaign efforts.

FJC faltered in the Great Depression and discontinued its operations in 1937. But growing anti-Semitism in Europe and the need to care for refugees from Nazism, meant that relief efforts needed to continue. The Milwaukee Jewish Council was formed in 1938, now being called the Milwaukee Jewish Council for Community Relations. In the same year, the Milwaukee Jewish Welfare Fund was established. The Jewish Vocational Service (now the Center for Independent Living) was set up to help find jobs for the latest arrivals to Milwaukee during that troubled era.

In 1944, the welfare fund created the Bureau of Jewish Education, now the Coalition for Jewish Learning. Two years later, the fund joined the United Jewish Appeal to help Jews make their way to Palestine and aid Holocaust survivors who came to Milwaukee. The fund changed its name to the Milwaukee Jewish Federation in 1971. The federation created endowment programs, organized mentoring sessions for young people to ensure continuity in leadership, built senior housing, and provided the financial fuel and creative energy to support many other causes. It remains the major umbrella organization of all things Jewish in the city.

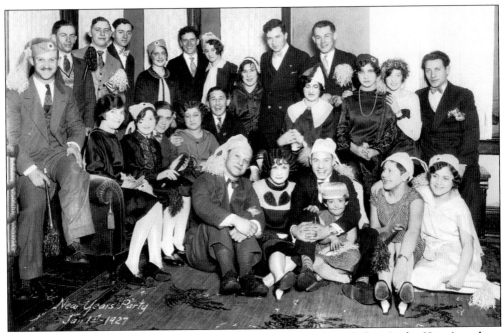

A group of friends gathered to celebrate the New Year of 1927, including Isador Katz (standing, third from left), Esther Chudnoesky (third from right) and Leo Sedlet (second from right). (Photograph courtesy of Robert E. Meder and the Milwaukee Jewish Historical Society.)

Julius Atkins was born in 1917 and was a graduate of North Division High School. He attended George Washington University at night while working a civil service job. Atkins went on to serve with distinction in the Navy during World War II. Afterwards, he became a real estate developer and was annual campaign chair of the Milwaukee Jewish Welfare Fund and a president of the Jewish Community Center. (Photograph courtesy of the Milwaukee Jewish Historical Society.)

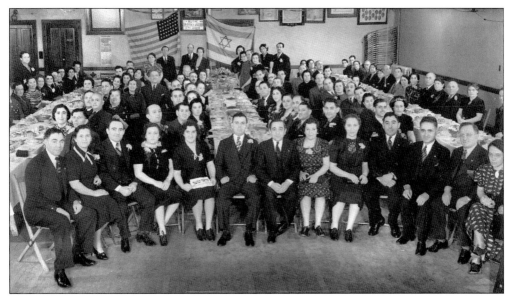

Members of the Dr. Syrkin Branch of the Poale Zion Organization celebrated their 10th anniversary on March 27, 1938. (Photograph by Stanfield's Studio, courtesy of the Milwaukee Jewish Historical Society.)

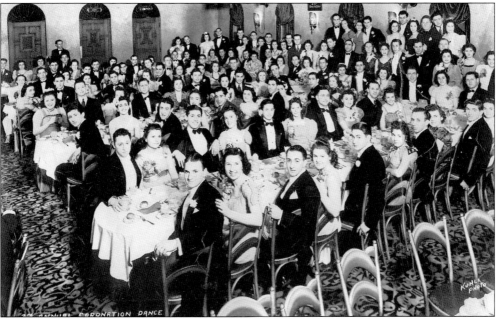

The third annual coronation dance of the B'nai B'rith Juniors was held on February 17, 1940. Crowned queen was Rose Rakita Wilk, with Herbert S. Wilk as king. Among those attending were Florence Hubart, Sol Kahn, Joe Fielkow, Norm Winnik, Darwin Huxley, Esther Ulevich, Bob Blink, Jeannette Shapiro, Hy Kastrul, Nate Wahlberg, Eli Gecht, Robert Appel, Julie Atkins, Pinky Mislove, Esther Spitz, Phil Siegel, Sonya Solocheck, Mickey Chernin, Herb Wilk, Rose Rakita, Jack Levings, Jerry and Annita Cramer, Arnold Plotkin, Lionel Rosenberg, Harry Sicula, and Henry Lerner. (Photograph by Kuhli Studios, courtesy of Darwin Huxley and the Milwaukee Jewish Historical Society.)

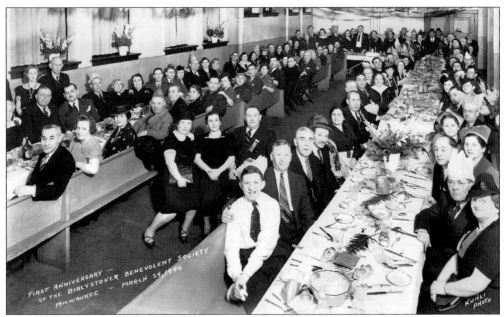

The first anniversary of the Bialystoker Benevolent Society was held on March 24, 1940. The group met for a number of years in Milwaukee for social gatherings and to raise funds for Jewish causes. The organization began in New York in 1897 when the Bialystoker Bikur Cholim was founded. (Photograph by Kuhli Studios, courtesy of Elaine Friedman and the Milwaukee Jewish Historical Society.)

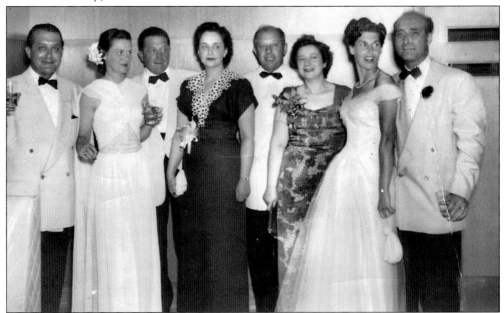

The opening of the Brynwood Country Club clubhouse in 1950 was a formal, but lively, occasion. Celebrating were, from left to right, Mr. and Mrs. Harry Kaminsky, Mrs. and Mrs. Red Kaminsky, Dr. and Mrs. Charles Stern, and Mr. and Mrs. Albert (Ollie) Adelman. The facility, located at 6200 West Good Hope Road, was founded in the 1930s, and the clubhouse was completed in the late 1940s. (Photograph courtesy of Albert Adelman.)

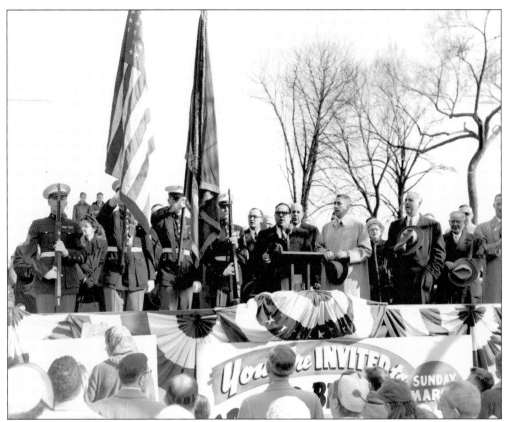

The 1953 groundbreaking for the Jewish Community Center on Prospect Avenue was a day for flags and speeches. Among the group on the podium were Rabbi Elkan Voorsanger, Ben Barkin, Sol Kahn, and Max Karger. More than 8,800 persons quickly joined the center. (Photograph courtesy of the Milwaukee Jewish Historical Society.)

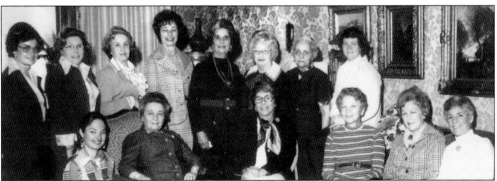

Among Jewish Family and Children's Service Auxiliary volunteers honored in 1975 were, from left to right: (first row) Mrs. Gerald Goldberg, Mrs. Alex Friedman, Mrs. Julian Hytken, Mrs. Bettie Frost, Mrs. Henry Pitt, and Mrs. Sidney Hack; (second row) Mrs. Arthur Siegel, Mrs. Jordan Werner, Mrs. Jack Silverman, Mrs. H. M. Rubnitz, Mrs. Harry Kramer, Mrs. Lillian Crawford, Mrs. Hy Chaimson, and Mrs. Donald Neuman. (Photograph courtesy of the *Wisconsin Jewish Chronicle*.)

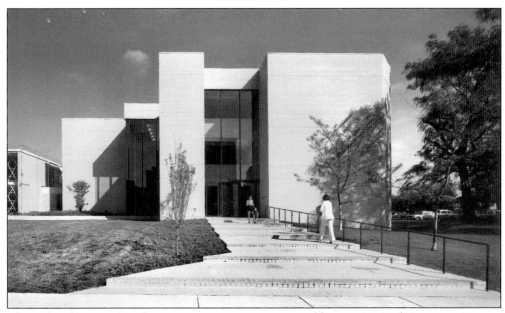

The Milwaukee Jewish Federation Community Service Building, 1360 North Prospect Avenue, opened in 1973 and was named after industrialist and philanthropist Evan P. Helfaer. Albert (Ollie) Adelman acted as chair of the building committee, aided by Sidney Kohl, Ben Marcus, Max Karl, and Gerald Kahn. As part of the complex, a home for the aged was constructed north of the center site. The facility's architect was the noted Edward Durell Stone. (Photograph by Balthazar Korab, courtesy of the Milwaukee Jewish Historical Society.)

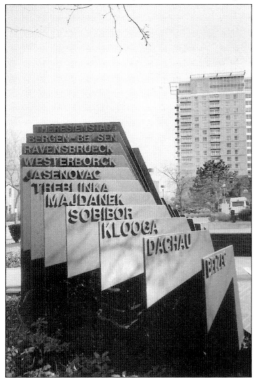

A memorial to the Holocaust victims, commissioned by the Milwaukee Jewish Federation in 1983, stands outside the Helfaer Community Service Building. Milwaukee-born Claire Lieberman designed the monument which resembles a book as a reminder that the Jewish people are "People of the Book." On the slabs are names of concentration camps. The base of the black granite column reads the Hebrew word, *Zachor*, meaning, "We remember." (Photograph by author.)

Members of the Ha-Kodimo Club celebrated their 50th anniversary on January 30, 1971. Among those pictured are Judge and Mrs. Max Raskin, Nancy and Phil Padden, Rod and Jody Padden, Minnie Perchonok, Mr. and Mrs. Joe Berliant, Gil and Dottie Palay, Carl and Sandy Zetley, Chuck and Helene Bernstein, Edith Erbstein, Dinky Holzman, Mickey and Lil Sattell, Seymour Perchonok, Dr. L. W. Blumenthal, Roz Perchonok Skurek, and Shirley and Elton Mendeloff. The organization of young Jewish men and women met for social and educational programs. (Photograph courtesy of Joe Berliant and the Milwaukee Jewish Historical Society.)

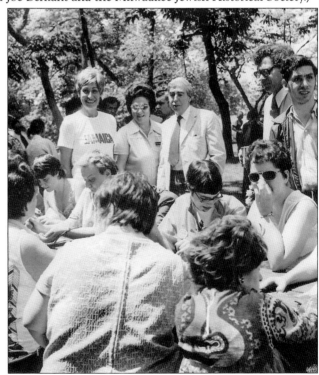

Staff and clients from the Milwaukee Center for Independence (formerly the Jewish Vocational Service) met with the late Milwaukee County Executive William F. O'Donnell. Pictured are Merle Wasserman, Jewish Vocational Services worker in adult programming; Peppi Dolberg, director of adult services; O'Donnell; and Joav Gozali, JVS associate executive director. Since 1938, the Center has been caring for the community. (Photograph courtesy of the *Wisconsin Jewish Chronicle*.)

43

Activist politician Bella Abzug (second from right) was a guest at the 1981 Women's Division campaign for the Jewish Federation. At her table were (from left) Betty Lieberman, Betsy Green, and Marsha Sehler. (Photograph courtesy of the Milwaukee Jewish Historical Society.)

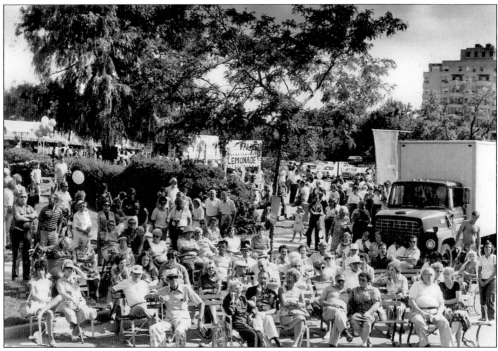

A diverse crowd enjoyed the festivities at the Milwaukee Jewish Jubilee of 1984 at the Jewish Community Center. Food, friends, music, and great weather characterized the jubilee of that year. (Photograph by Andy Muchin, courtesy of the *Wisconsin Jewish Chronicle*.)

Angel Benavides (center), manager of the National Council of Jewish Women Thrift Shop, and volunteers Jane Shlimovitz (left) and Edith Mann, discuss the marking of items for sale. In the mid-1940s, the Council took over operations of the gift shop from the Women's League for Jewish Education, which originally ran the shop from 1939 to 1944. (Photograph courtesy of the *Wisconsin Jewish Chronicle*.)

Milwaukee Jewish Welfare Fund members Richard Bamberger (left) and Ed Elkon (right) met with writer Yaacov Morris at a Community Division meeting as part of the 1967 campaign. Other important local leaders helping raise funds that year included Marvin Klitsner, Julius Atkins, Allen Kohl, Paul Elias, Larry Orenstein, Richard Goldberg, Gerald Levy, Jim Peterman, Stuart Brafman, Don Sandler, Pat Kerns, and Herman Cowan. (Photograph courtesy of the Milwaukee Jewish Historical Society.)

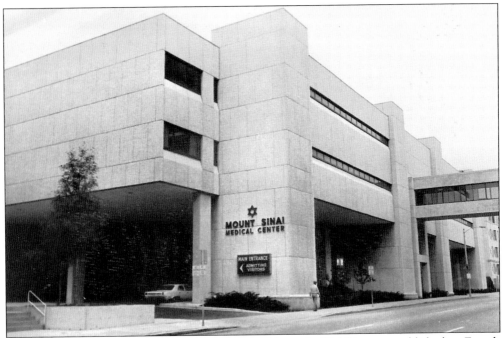

The first Mount Sinai Hospital, in a building rented from the YMCA, was established on Fourth and Walnut Streets to serve the immigrant Jewish population of the city. As the hospital grew, moving to what is now Twelfth Street and Kilbourn Avenue, intern and residency programs were established. As costs rose by 1987, services were merged with the Good Samaritan Medical Center, now Aurora Health Care. (Photograph courtesy of the Milwaukee Jewish Historical Society.)

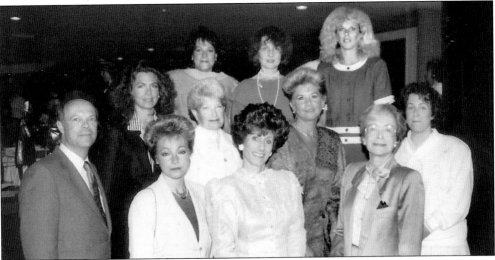

In 1988, Gloria Golding (first row, center) was named the new president of the Mount Sinai Auxiliary of the Sinai-Samaritan Medical Center. A ceremony was held at Brynwood Country Club. The new auxiliary officers were, from left to right: (first row) Jim Plous, Vicki Chiger, Gloria Golding, and Barbara Heilbronner; (second row) Julie Deleeuw, Toots Hassel, Terry Goodman, and Debbie Cohen; (third row) Marley Stein, Peggy Bernstein, and Netty Sattler. (Photograph courtesy of the *Wisconsin Jewish Chronicle*.)

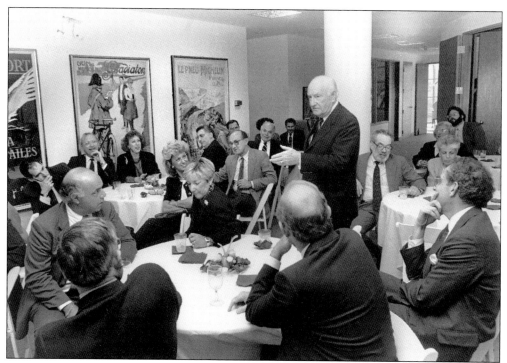

Ben Marcus led a discussion on the Passage to Freedom Campaign in 1989, urging support for the Jewish Federation's drive to resettle and educate 40,000 Jewish émigrés from what was then the Soviet Union. Among the newcomers making their homes in Milwaukee during this time were Edward Kagan, Michael Perelshtein, and Fred and Yergenia Kleytman.

Doug Jacobson and Rachel Heilbronner had a great time demonstrating their smooth moves at a B'nai B'rith Youth Organization dance in January, 1996. (Photograph courtesy of the *Wisconsin Jewish Chronicle*.)

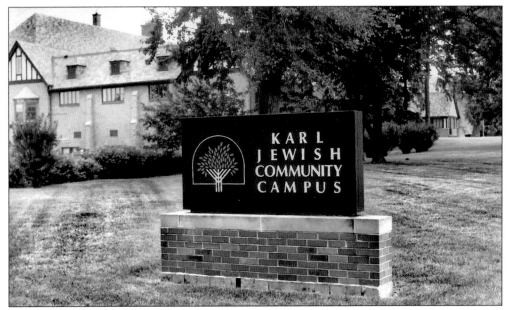

The Max and Anita Karl Jewish Community Campus is named in honor of one of Milwaukee's most notable couples. Karl was a graduate of the University of Wisconsin and its law school, going on to found the Mortgage Guaranty Insurance Corporation, headquartered in Milwaukee. He served as past president of the Mortgage Insurance Companies of America and as a director of First Wisconsin Corporation and MGIC affiliates. In addition to many civic roles, he served as president of the Milwaukee Jewish Federation and was chairman of Wisconsin State of Israel Bonds. This photograph shows Karl with Louise Eder and Golda Meir in 1974. He died at age 85 in 1995. (Upper photograph courtesy of the *Wisconsin Jewish Chronicle*; lower photograph courtesy of the Milwaukee Jewish Historical Society.)

Volunteers honored in 2004 for aiding Keshet of Wisconsin were, from left to right, Jody Margolis, Phyllis Brenowitz, and Cantor Karen Berman of Congregation Shalom. Keshet, a program of the Jewish Family Services, supports youngsters with special needs. (Photograph by Mike Rice, courtesy of the *Wisconsin Jewish Chronicle*.)

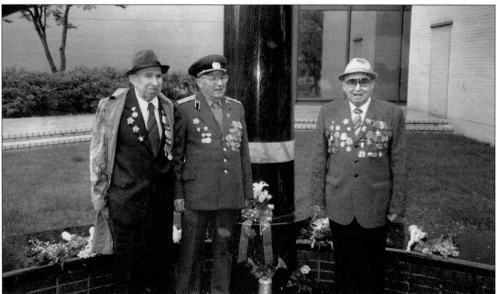

Soviet army veterans brought floral arrangements to the Milwaukee Jewish Federation's Holocaust Memorial on May 9, 2000. The celebration marked Victory Day, the Russian holiday marking the end of the war against the Germans in 1945. Decked out in their medals were Gdal Klugman (left) and Ruvin Kinkulkin (right). The man in the center is not identified. (Photograph courtesy of the *Wisconsin Jewish Chronicle*.)

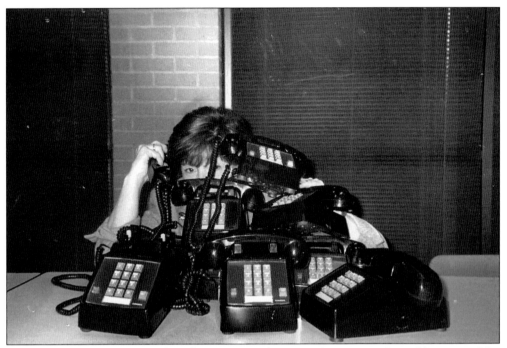

Margie Stein, Milwaukee Jewish Federation special projects director, was buried by some of the 45 phones used for the 2000 Super Sunday. The event, along with Super Week, raises money for the federation. (Photograph courtesy of the *Wisconsin Jewish Chronicle*.)

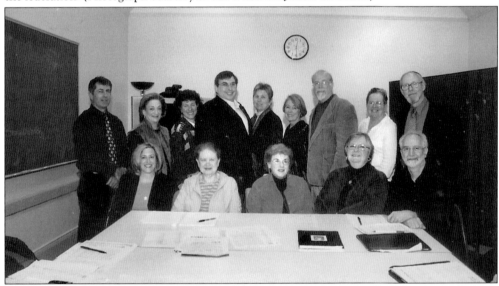

The 2005 "A Day of Discovery" committee is shown taking a break from their planning sessions. The event was supported by the Wisconsin Council of Rabbis, the Milwaukee Jewish Federation's Coalition for Jewish Learning, and the Jewish Community Center. Those on hand included, from left to right: (sitting, first row) Bonnie Shafrin, Rena Safer, Barbara Abrams, Kathy Jendusa, and David Blumberg; (standing, second row) Alon Galron, Diane Hahn, Eileen Graves, Rabbi Steven Adams, Sharon Wasserberg, Dorene Paley, Jody Hirsh, Judy Eglash, and Steve Baruch. (Photograph courtesy of the *Wisconsin Jewish Chronicle*.)

Four

LEARNING AS A
WAY OF LIFE

Love of learning is the heart and soul of Jewishness. As such, schooling has always been considered an important means of preserving culture. The Bureau of Jewish Education was formed in 1944 to promote and coordinate distinctly Jewish education in Milwaukee. Its first director was Meyer Gallin. Prior to this organization were the Joint Committee on Jewish Education and the Milwaukee Talmud Torah Association. Affiliated with the bureau were the Beth Israel and United Hebrew Schools, the Milwaukee Talmud Torah, and the Yiddish Folk Shule.

Synagogues still offer classes in Hebrew and Judaica, augmenting classes offered by day schools. The Coalition for Jewish Learning, the education program of the Milwaukee Jewish Federation, currently serves Milwaukee's Jewish preschools, Jewish day schools, supplementary schools, and various informal Jewish education programs. It also facilitates the introduction of Jewish family education in several synagogues and agencies and coordinates the Jewish Family Educators Council.

Milwaukee Jewish Day School (MJDS) is located in the Kohl Education Building, 6401 North Santa Monica Boulevard, as part of the Karl Jewish Community Campus owned and operated by the Milwaukee Jewish Federation. MJDS began with an enrollment of 11 kindergarten students in the fall of 1981, with current enrollment remaining steady at about 340 students. Eighty full and part-time staffers teach youngsters representing Reform, Conservative, Orthodox, and Reconstructionist affiliations.

Other educational institutions in Milwaukee included the Wisconsin Institute for Torah Study, founded in 1980 as an Orthodox Yeshiva with almost 200 students from around the United States and from Israel, Hillel Academy was the first community day school, and in 1989, the Yeshiva Elementary School was founded.

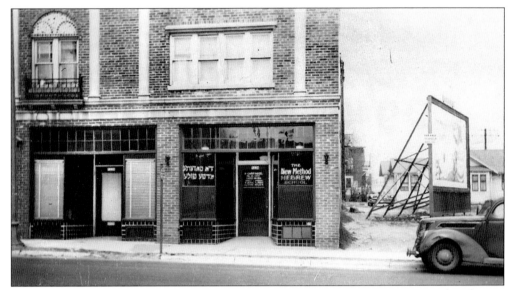

Russian-born Harry Garfinkel founded the New Method Hebrew School in Milwaukee in 1914 after first giving lessons in private homes. The school taught youngsters enough Hebrew language and history so that they could read their prayer books at religious services. The school also organized the Young Children of Israel (1919), the Hatikva Circle (1924), and the Junior Jewish Forum (c. 1934). The school closed when Garfinkel died in 1964. (Photograph courtesy of Belle Garfinkel and the Milwaukee Jewish Historical Society.)

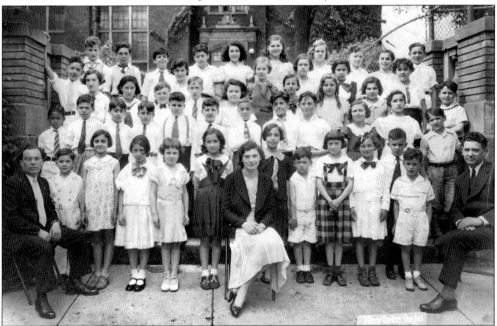

Youngsters gathered around their teachers at the Milwaukee Folk Shule, launched in 1911 by the Socialist Zionists. Members of the group had broken with traditional education programs, seeking to educate their children in secular nationalism. By 1915, 120 youngsters were attending Saturday and Sunday classes in the Talmud Torah building and the Abraham Lincoln House. (Photograph courtesy of the Milwaukee Jewish Historical Society.)

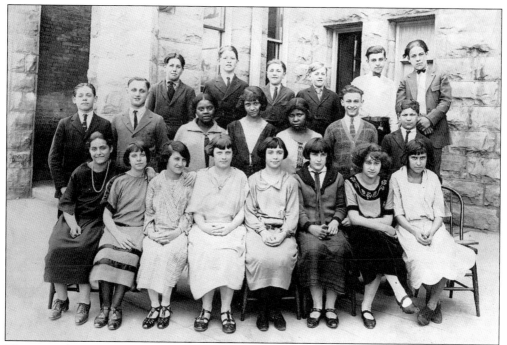

This 1924 class at the Fourth Street School (now Golda Meir School) included Harry Gorbitz (third row, far right), Sol Kosberg, Hy Popuch (second row, far left), Libby Kosberg (first row, second from left), Minnie Margolis (first row, second from right), and Katie Holzman (first row, far right). (Photograph courtesy of Sol Kosberg and the Milwaukee Jewish Historical Society.)

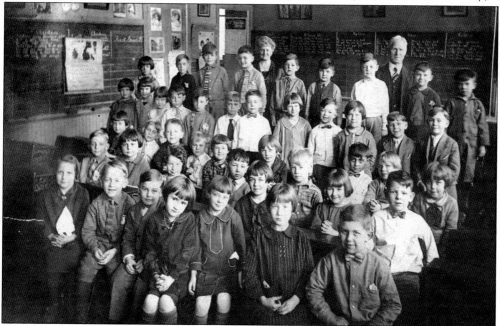

The combined first grade classes of the Tenth Street and Lee Street Schools gathered for a photograph around 1926. Nattily attired in his bow tie, Nathan W. Krasno was seated in the third row, third from right. (Photograph courtesy of the Milwaukee Jewish Historical Society.)

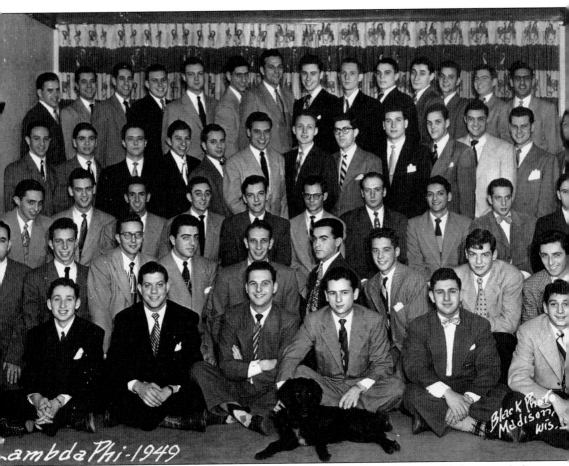

Members of the Pi Lambda Phi fraternity at the University of Wisconsin-Madison, including many young men from Milwaukee, paused from their studies in 1949. Pictured from left to right are: (first row) Bill Raab, Eliot Deutsch, Harold Paley, Gene Eder, Dave Marcus, Noah Mulstein, Harvey Weinberg, Bob Martin, Bob Fin Gleimer, Mackey Spero, Leo Romanik, Ed Schneiderman, and Bob Gold; (second row) Shelley Fink, Laurie Hurwitz, Gordon Devorkin, Bob Fink, Jerry Wallace, Barry Elman, Al Bernstein, George Mesberg, Bill Isaacson, Bob Baratz, Bob Miller, Leon Goldberg, and Rich Lang; (third row) Jim Shapiro, Buzz Kramer, Bob Miller, Sheldon Lubar, Gil Paley, Joe Biller, Jordan Miller, Perry London, Adolf Stern, and unidentified; (fourth row) Jack Shlimovitz, David Rice, Richard Goodman, Gene Shapiro, Bob Rice, Paul Meissner, Victor Goodman, Burt Strnad, and Fred Cohen; (fifth row) Fred Sherman, Howard Wittenberg, Manny Shimberg, Bob Weiss, Gordon Winston, Dick Lapp, and Jack Oppenheim. Pi Lambda Phi, which was the first nonsectarian fraternity in the country, celebrated its 100th year in 1995 at Yale University, the site of its founding. The Omega chapter at the university was started in 1926. (Photograph courtesy of Sheldon and Marianne Lubar and the Milwaukee Jewish Historical Society.)

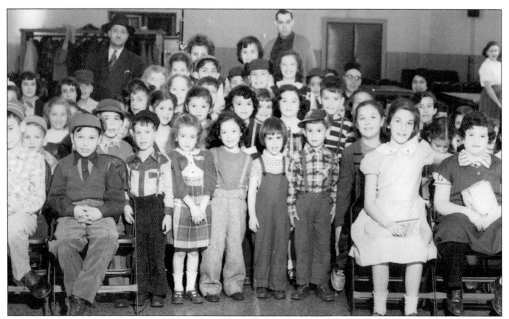

This Sunday School class for Congregation Beth Israel in the early 1950s was under the tutelage of Principal Carl H. Schulman (center rear) and Cantor Moses Serensen. Among the youngsters were Marcy Herman (first row, center in bib overalls) and Florine Bobbie Schulman Fishman (far left behind the boy in the stocking cap). The other children are unidentified. (Photograph courtesy of the Milwaukee Jewish Historical Society.)

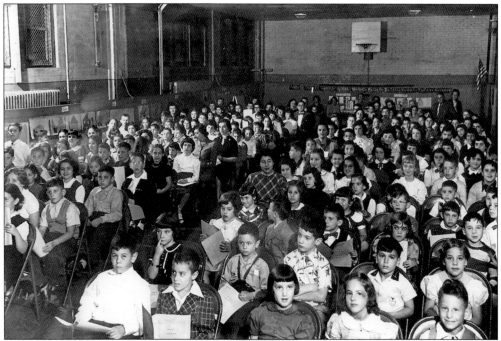

In the early 1950s, the first classes of the Congregation Shalom school were held at Cumberland School. Here, eager youngsters were ready for a program in the school's gymnasium. (Photograph courtesy of Congregation Shalom.)

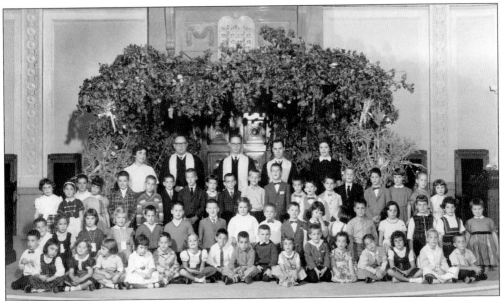

Rabbi Dudley Weinberg was surrounded by youngsters at Temple Emanu-El B'ne Jeshurun. Weinberg was an active figure within the executive committee of the Central Conference of American Rabbis, the Reform organization in the United States. A civil rights leader, he was also a respected scholar. When Weinberg died in 1976, he was working on a commentary for the *Book of Deuteronomy*. (Photograph courtesy of the Milwaukee Jewish Historical Society.)

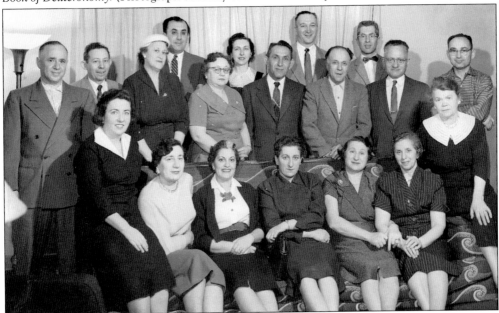

The board of the United Hebrew Schools gathered for a portrait in 1957. Pictured from left to right are: (first row) Gertrude Silverstein, unidentified, Dorothy Teplinsky, Irene Shaw, Etta Ellman, Esther Bodner, and unidentified; (second row) Max Silverstein, Jessie Saxe, Ida Gaer, Sam Gaer, unidentified, Morris Ellman, and Herman Weingrod; (third row) George Teplinsky, Jack Spector, Esther Spector, Mr. Hafferman, and Morris Gross. (Photograph by Kuhli Studios, courtesy of the Milwaukee Jewish Historical Society.)

In 1974, scholarship students from the B'nai B'rith Institute of Judaism beamed for the camera. Pictured from left to right are: (seated, first row) Carol Lorman, Beney Browne, Susan Zukrow, and Nancy Epstein; (standing, second row) Howard Sanager, Steve Rudman, Gregg Herman, Dan Strnad, and Jeffrey Altshul. (Photograph by Norman Friedmann, courtesy of the *Wisconsin Jewish Chronicle*.)

Proud graduates of the East Side Hebrew School stood for their portrait after a ceremony in 1977. Pictured from left to right are: (first row) Jill Grande, Cynthia Jacobs, Heidi Goldberg, Ann Bratt, and Connie Friedman; (second row) teacher Noni Siegel, David Margolis, Gary Berman, Larry Stein, William Goldstein, teacher Aaron Petuchowski, Michael Heller, and Gregory Bradbury. (Photograph courtesy of the *Wisconsin Jewish Chronicle*.)

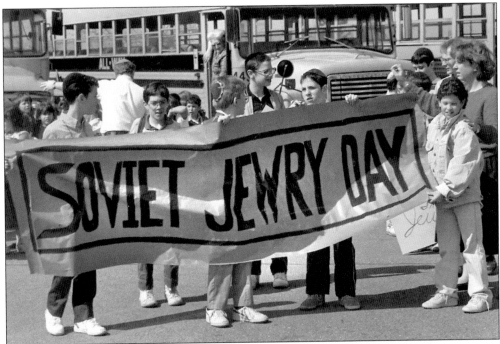

Hillel pupils held a banner during a rally on Soviet Jewry Day in April 1987. The demonstration was part of a national move within the United States to voice displeasure about the lack of freedoms endured by Jews living in the Soviet Union. (Photograph by Linda Erlien, courtesy of the *Wisconsin Jewish Chronicle*.)

The Wisconsin Institute for Torah Study (WITS) launched its Great Lakes Sefer Torah Project in 1992. Quill pens were given to children watching scribe Yerachmiel Askotzky as he wrote. The document was then circulated throughout Wisconsin and other Midwestern states as a project to unify Jewish communities. Rabbi Raphael Wachsman directed the project. (Photograph by Leon Cohen, courtesy of the *Wisconsin Jewish Chronicle*.)

Hillel Academy was founded in 1960, making it the oldest Jewish day school in the greater Milwaukee area. This photograph shows one of its earlier homes, at the former Layton School of Art and Design on North Port Washington Road in Glendale. The school is now situated in the Rubenstein Center for Jewish Studies in Fox Point, part of the Karl Jewish Community Campus operated by the Milwaukee Jewish Federation.

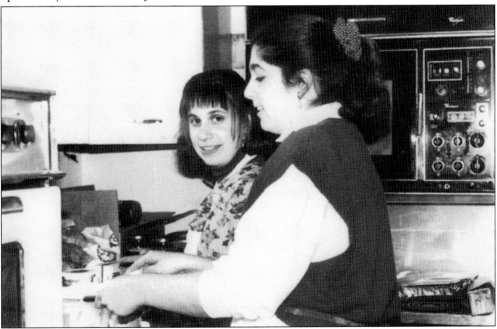

University of Wisconsin-Milwaukee alumni Ilene Sand (left) and Rona Wolfe prepared *Shabbat* dinner in the cramped Hillel House kitchen. Both women met their husbands at similar dinners. That day, the two served 50 hearty eaters. (Photograph courtesy of the *Wisconsin Jewish Chronicle*.)

Six high school seniors graduated in 1988 from Tichon-Milwaukee Judaica High School, sponsored by the Milwaukee Association for Jewish Education. Pictured from left to right are: (first row) Tamie Bodner, Tammy Moses, and Amy Shidler; (second row) Ilan Chorowsky, Peter Himmelfarb, and Jonathan Levy. Each student earned a diploma.

The Child Development Center of Jewish Family Services celebrated its 10th anniversary with a picnic and parade in 1996 at the Karl Jewish Community Campus. The parade was led by Friends Mime Theatre. The party was cochaired by Bob and Felice Lieb and Hal and Barbara Karas. (Photographs courtesy of the *Wisconsin Jewish Chronicle*.)

Since opening in 1986, the Karl Campus has provided a home for the JCC, Hillel Academy, Milwaukee Jewish Day School, B'nai B'rith Youth Organization, the Coalition for Jewish Learning, JFS Child Development Center, and Children's Lubavitch Living & Learning Center. The facility was purchased by the Milwaukee Jewish Federation through the generosity of Max Karl. (Photograph courtesy of the Milwaukee Jewish Historical Society.)

Milwaukee Jewish Day School fifth grader Andrew Leib "charmed" a snake during his presentation on the culture of India at the 2000 Folk Fair. Pupils studied various countries and then shared their knowledge with other classes and members of the community. (Photograph courtesy of the *Wisconsin Jewish Chronicle*.)

Nicolet High School sophomore Tera Greenberg helped a friend during a Hebrew language program at Nicolet High School in 2000. To the left was junior Jon Schutkin. (Photograph courtesy of the *Wisconsin Jewish Chronicle*.)

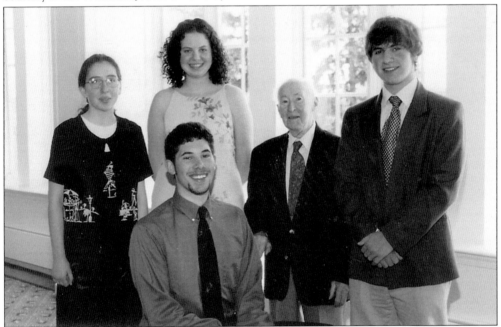

A luncheon at Brynwood Country Club honored the 2001 recipients of the Richard H. Hecht and Norma Hecht Memorial College Scholarships, hosted by the Jewish Community Foundation, which is the endowment program of the Milwaukee Jewish Federation. Pictured with Harry Hecht are Daniel Kahn (seated) and from left to right, Ronit Slyper, Terri Kulakow, and Eugene Morgulis, who each received $5,000 for college. The scholarships were developed in memory of Richard Hecht, Harry's son, who died in 1996, and his wife Norma, who died in 2000. (Photograph courtesy of Cliff Erickson, Epic Images, and the *Wisconsin Jewish Chronicle*.)

Five

PEOPLE OF THE WORD

In the first known celebration of a Jewish holiday in Milwaukee, 12 pioneering Jews held a Yom Kippur service in 1847 at the home of grocer Isaac Heustadtl. In the following year, Milwaukee's first Rosh Hashana services were held at Henry Newhouse's home. Other early Yom Kippur services were conducted above Nathan Pereles' grocery store.

Congregation Imanu-Al, the first temple organized in Milwaukee, opened in 1850, with David Adler as president. Next came Congregation Ahabath Emuno, founded in 1854 with Simon Levy as president. Nathan Pereles was named president of B'ne Jeshurun, when it was founded in 1856. From those seeds grew today's spectrum of synagogues, ranging from Anshe Sfard Kehillat Torah to the Shul East.

Generally speaking, Milwaukee's Reform congregations were originally downtown and moved to the east side and northeastern suburbs. Eastern European congregations, once mostly situated on the near north side, have moved west and northwest. The Conservative, Orthodox, and Reconstructionist movements have found homes in the Sherman Park area and in Mequon.

The first Jewish burial in Milwaukee occurred in 1848, followed by the establishment in 1850 of what was then called Imanu-Al Cemetery. The "Jews' Cemetery," located at what is now Hopkins and Chambers Streets in the 1850s and 1860s, became known as the *Shaarei Tzedik* (Gates of Righteousness), where records were kept in German. The grieving were served through the Milwaukee Jewish Burial Sacred Society. Jewish cemeteries include Anshai Lebowitz, Beth Hamedrosh Hagodel, Greenwood, Mound Zion, Second Home, Spring Hill (B'nai B'rith), and Temple Menorah Ever-Rest.

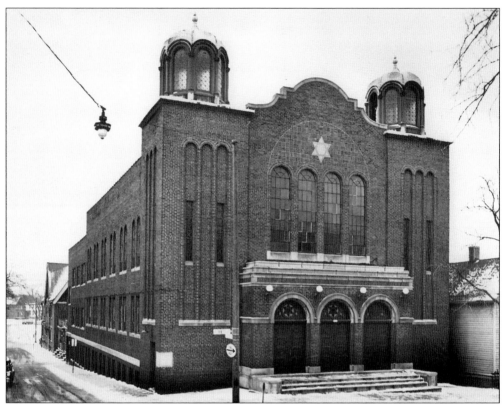

A group of Russian Orthodox Jews founded Congregation Anshai Lebowitz after emigrating to Milwaukee in the late 19th century. First holding services in a private home on lower Vliet Street, these Lubavicher Chassidim acquired a building at the corner of North Eighth and West Walnut Streets in 1911. By the 1920s, the growing congregation had built a synagogue at North Eleventh and West Reservoir Streets. The congregation remained there until 1953 when it constructed a new facility at North Fifty-Second and West Burleigh Streets. However, by the 1960s, the congregation waned and it moved to Mequon in the late 1990s. (Photographs courtesy of the Milwaukee Jewish Historical Society.)

Rabbi Solomon Schulson oversaw the move of Congregation Anshai Lebowitz to its new building, at 3100 North Fifty-second Street, in 1953. At the time, Morris Segel was president and Mrs. Allen Shafrin was president of the board of education. Schulson served the congregation from 1943 to 1964. Descended from 10 generations of rabbis, Schulson was ordained in 1915 by the chief rabbi of Jerusalem. He is buried in Israel.

Rabbi Solomon Scheinfeld was born in 1860 in Lithuania and came to Milwaukee shortly after being ordained in 1890. He served the city's first Orthodox congregation, Beth Hamidrosh Hagodol, and also led Congregation Beth Israel. He was chief rabbi of the United Orthodox Congregations of Milwaukee until his death in 1943.

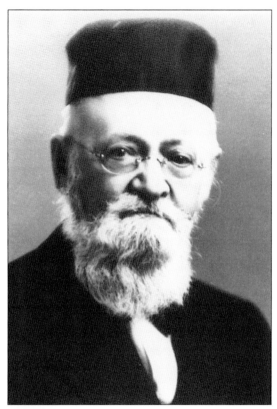

Many of Jacob Twerski's ancestors were noted rabbis so it was natural that he also became a spiritual leader. He came to Milwaukee in 1928 to serve at Congregation Anshe Sfard. In 1929, Twerski founded Congregation Beth Jehudah. His youngest son, Michael, became rabbi of Beth Jehudah, and his grandson Benzion became that congregation's assistant rabbi. They coordinated a thriving religious community, including the Yeshiva Elementary School and the Milwaukee Kollel. (Photographs courtesy of the Milwaukee Jewish Historical Society.)

Rabbi David Shapiro was a scholar and teacher who graduated from the Hebrew Theological College. He came to Milwaukee to serve Congregation Anshe Sfard in 1948. In addition to his rabbinical duties, Shapiro taught at the University of Wisconsin-Milwaukee and Ben Gurion University in Israel. Shapiro was active in the Wisconsin Council of Rabbis and worked on numerous interfaith projects. He also founded Hillel Academy in 1968. Shapiro died in Israel in 1989. (Photographs courtesy of the Milwaukee Jewish Historical Society.)

Rabbi Jay Brickman wrote several volumes of essays, including *Reflections in a Pumpkin Field* (1989) and *Reflections on a Lily Pond* (1997). Originally from New York, Brickman helped found Congregation Sinai in 1955. He retired in the mid-1990s and turned to teaching at the University of Wisconsin-Extension. He was also a president of the Interfaith Conference of Milwaukee and a member of the Fox Point village board.

Morry Mitz proudly posed for his bar mitzvah portrait in 1935. (Photograph courtesy of the Milwaukee Jewish Historical Society.)

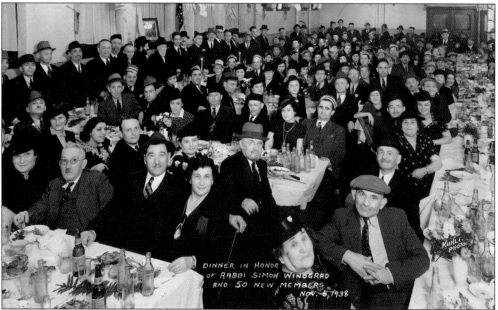

A dinner in honor of Rabbi Simon Winograd of the Congregation Anshai Lebowitz was held November 6, 1938, attended by dozens of his congregation and friends. Winograd served the congregation from 1938 to 1944. (Photograph by Kuhli Photograph Studio, courtesy of the Milwaukee Jewish Historical Society.)

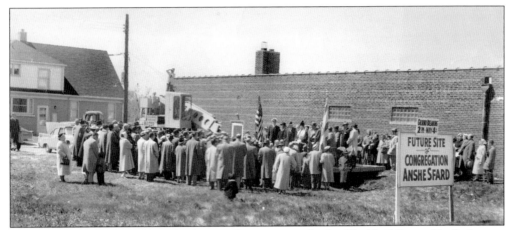

The ground-breaking ceremony for the new Congregation Anshe Sfard building, at Keefe Avenue and Fifty-first Boulevard, attracted a crowd in the spring of 1958. Its initial service was held on the first night of Selichos that year. The congregation, one of the oldest in Wisconsin, was organized in 1893 by settlers from southwestern Russia who followed the Hasidic ritual. From 1948 to 1983, Rabbi David Shapiro shepherded the congregation. By 1989, the congregation had dwindled and the building was sold. At one time, the congregation had more than 1,000 families. (Photograph by Samuel Dorfman, courtesy of the Milwaukee Jewish Historical Society.)

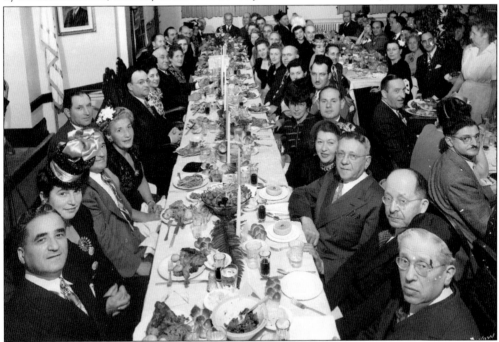

A dinner honoring Rabbi and Mrs. Louis J. Swichkow of Beth El Ner Tamid Synagogue was held on March 23, 1947. They are the third couple seated on the left side of the table. Among those attending were Rabbi Maurice Cornfield, Mr. and Mrs. Aaron Nerdorf, Mr. and Mrs. Hyman Peckarsky, George Rosenberg, Mr. and Mrs. Nathan Stein, and Mr. and Mrs. Herman D. Schwartz. After 48 years with his congregation, Swichkow became Rabbi Emeritus. Among his many books, he coauthored *The History of the Jews of Milwaukee* (1963). (Photograph courtesy of the Milwaukee Jewish Historical Society.)

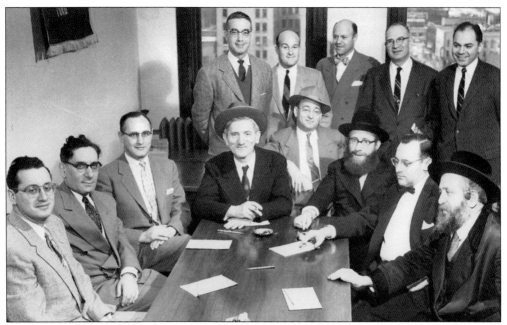

A council of Milwaukee's rabbis and other leaders of the Jewish community gathered, c. 1956, to discuss their mutual challenges. Pictured from left to right are: (seated) Rabbis Paul Greenman, David Shapiro, Harry Pastor, David Becker, Louis Swichkow, Israel Feldman, Jay Brickman, and Jacob Twerski; (standing) Larry Katz, Bernie Sampson, Harry Plous, Morris Weingrod, and Melvin Zaret. (Photograph courtesy of the Milwaukee Jewish Historical Society.)

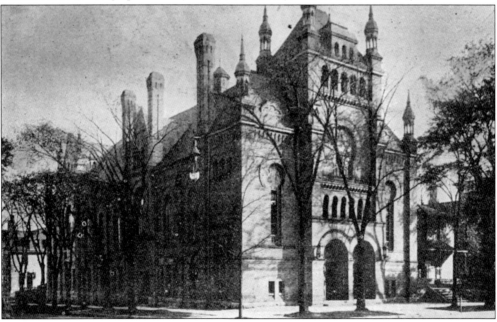

In the late 1880s, the B'ne Jeshurun synagogue offered a sanctuary that seated 750 worshippers. It stood at Tenth and Cedar Streets (now Kilbourn Avenue) where the current Milwaukee County Courthouse now stands. The Reform congregation's original temple had been at Broadway and Martin Streets for 51 years. (Photograph courtesy of the *Wisconsin Jewish Chronicle*.)

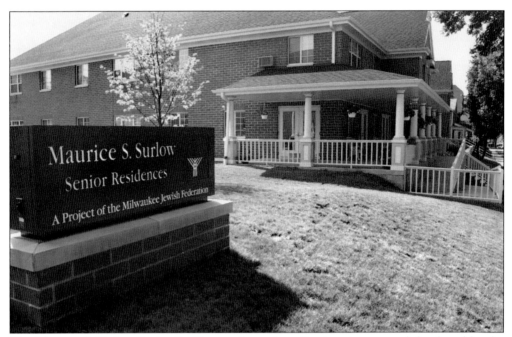

The Maurice S. Surlow Senior Residences, located on Bartlett Avenue and developed by the Milwaukee Jewish Federation for low income elderly, typifies the wide range of social services available to the city's Jewish community. (Photograph courtesy of the Milwaukee Jewish Historical Society.)

Rabbi Harry B. Pastor came to Milwaukee from Peoria, Illinois, in 1947 as associate pastor at Emanu-El B'ne Jeshurun. In 1951, he became rabbi of Congregation Shalom. Pastor saw its membership grow to 435 families in three years. Rabbi Pastor retired in 1980 and died in 1988. (Photograph courtesy of Congregation Shalom.)

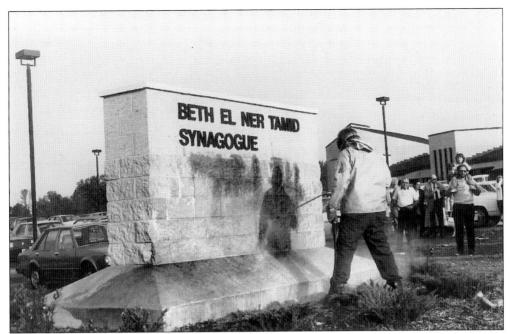

Milwaukee was not immune to the world's political turmoil. Swastika paintings on synagogues throughout the area in 1984 necessitated cleanup operations such as this one at Beth El Ner Tamid Synagogue.

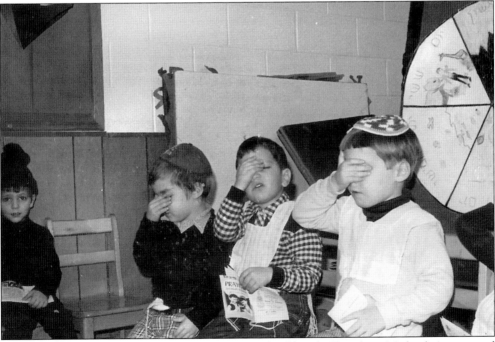

While reciting the *Shema Yisroel*, Lubavitch pupils Eklanah Shmokin, Michael Anton, and Shloma Perlstein covered their eyes. The first passage in the Mezuzah taken from the Torah is the basic belief of all Jews. "Hear O Israel, the Lord our God, the Lord is One" is perhaps the most famous of all Jewish sayings. (Photographs courtesy of the *Wisconsin Jewish Chronicle*.)

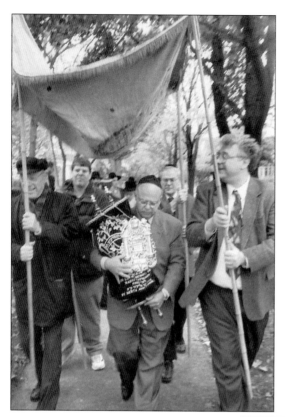

In November 2000, marchers walked along Hackett Avenue toward the Lake Park Synagogue during a commemoration of the 62nd anniversary of Kristallnacht, the "Night of Broken Glass." Participants marked the 1938 pogrom in which Nazi Germans attacked Jewish businesses, homes, and synagogues.

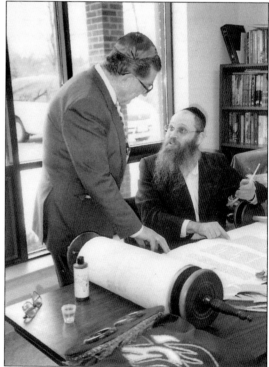

Dan Raviv (left) and scribe Moshe Klein had an intense discussion over a Torah reading at Congregation Agudas Achim Chabad. (Photographs courtesy of the *Wisconsin Jewish Chronicle*.)

In 2001, then Milwaukee County Executive, Thomas Ament (left) received a plaque containing a silver dollar, rental for the land on which the Glendale *eruv* sits. The presentation was made by Rabbi Nachman Levine of Anshe Sfard Kehillat.

In March 2001, former Milwaukee community chaplain Rabbi Dr. Tsvi Schur (standing), guest speaker at the Chevre Kadisha's annual dinner in Glendale, congratulated society member Irv Kadwit. Rabbi Jack Anton presented an award to Kadwit, who was the society's oldest member. (Photographs courtesy of the *Wisconsin Jewish Chronicle*.)

Tomer Zohar, brother of slain Israeli serviceman and peace activist Maj. Amir Zohar, lit a torch symbolizing the 12 Tribes of Israel. The commemoration marked the beginning of Yom HaAtzmaut (Israeli Independence Day) on April 25, 2001. The candle lighting at Congregation Sinai followed a ceremony recalling victims of terror. (Photographs courtesy of the *Wisconsin Jewish Chronicle*.)

Marnina Rubin and her brother, Yaakov, lit the chanukah menorah for the Celebration of Lights held in December 2001, at St. Joseph's Hospital. The program, sponsored by the Sherman Park Association of Religious Communities, celebrated the cultural diversity in the area and marked Christmas and Kwanzaa, as well as Chanukah. The event included a kosher dinner prepared by Congregation Beth Jehudah.

Six

BUSINESS MATTERS

The story of Milwaukee's Jewish business scene is one of determination. The city has always been a mecca of opportunity. Mills, slaughterhouses, breweries, industrial plants, and commercial enterprises provided plenty of possibilities for new arrivals. Thinking big and working hard have always gone hand-in-hand.

Many astute Jewish businessmen started with little or no money but were gifted with an abundance of enthusiasm. Retailers Henry Stern, Henry M. Mendel, Marcus Stein, and Adolf W. Rich were among the area's most successful entrepreneurs in the days before the Civil War. Bernard Heller, who came to Milwaukee from Bohemia in 1846, was the city's first sausage maker. Founded in 1868, Milwaukee's Lake Superior Navigation Company was one of the Great Lakes' largest freight companies. The firm was the brainchild of Henry F. Leopold, who with his brothers—Samuel, Lewis, and Aaron—had a lucrative trade with Wisconsin's Native Americans.

The manufacturing of clothing, shoes, and boots drew a large percentage of skilled Jewish craftsmen, such as Emanuel Shoyer who opened a tailor shop. Jewish clothing and retail manufacturing became well-established on Water Street. Today's Old World Third Street was once home to numerous businesses owned by Jewish families, as was the upscale shopping district from Lloyd Street to Clark Street. Milwaukee's main store was Schusters, located at the bustling corner of Third Avenue and Garfield Street. Clothing shops were named after their owners: Rosenbergs, Bitker-Gerner, Routts, Brills, and Karps.

The economic door swung wide for anyone in any trade. Solomon Roth was noted in the tobacco trade. Joseph Schram opened a grocery store. Harry Bragarnick was a dry goods retailer and freelance labor arbitrator. Kohl, Peltz, Rubenstein, Lando, and Tolkan are among the many other names that symbolize what determination and acumen can accomplish.

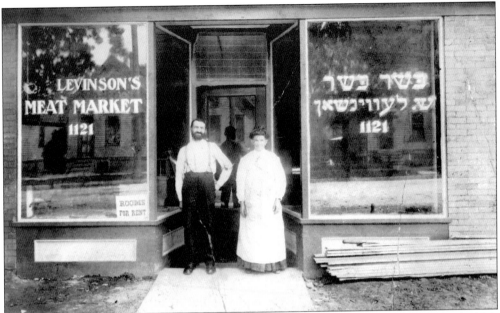

Levinson's Meat Market was a thriving shop at 1121 West Walnut Street in the early 20th century. Shmuel and Chaya Levinson emigrated to Milwaukee from Riga, Latvia. (Photograph courtesy of Jacqueline Glickman Horstein and the Milwaukee Jewish Historical Society.)

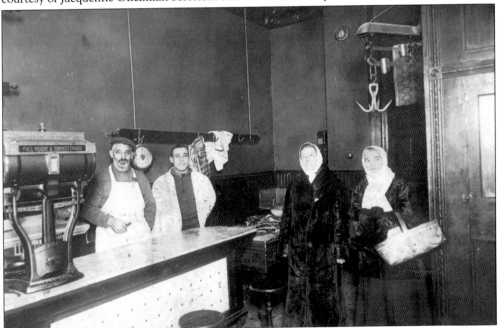

Max and Dora Silber's meat market, at 610 North Tenth Street was a popular place to meet and talk in 1917. Their daughter, Ida, married Milwaukee businessman and inventor George Bursak. The couple left a fund of more than $1 million for the support of local Jewish community causes and projects, in addition to helping Lubavitch of Wisconsin construct a chapel at the Chabad Lubavitch House and aiding Anshe Sfard Kehillat Torah. (Photograph courtesy of the Milwaukee Jewish Historical Society.)

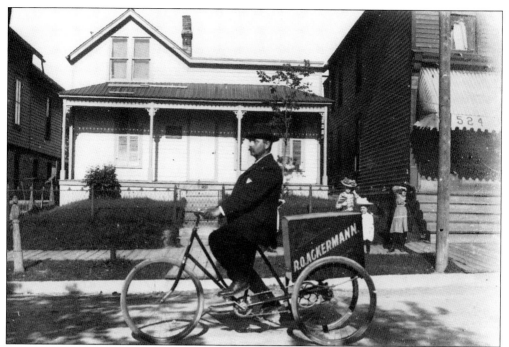

Rudolph Ackermann worked out of his home in the 1400 block of South Tenth Street and delivered his cigars throughout the neighborhood. In this scene from 1902, Ackermann cut quite a dashing figure as he pedaled along on his rounds.

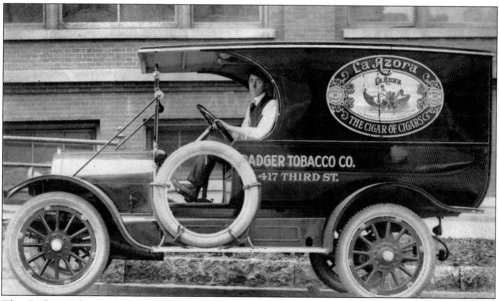

This Badger Tobacco Company deliveryman made his rounds in 1915. Earlier Jewish businessmen also providing tobacco products in Milwaukee were Moses and Solomon Roth, who launched their company in 1854. In 1858, Bernard Liedersdorf started a similar distribution operation, went on to be a Milwaukee alderman and served a year as commissioner of public debt. (Photographs courtesy of the Milwaukee Jewish Historical Society.)

Morris Waisman was proud of his bookstore at 722 West Walnut Street. He escaped the pogroms of czarist Russia and came to the United States by way of Canada in 1907. Waisman arrived in Milwaukee in 1910, hearing about the city's liberal political scene. In 1916, he opened his bookstore and a soda shop. Waisman and his wife, Rachel, also wrote letters for illiterate immigrants and were witnesses when newcomers sought their naturalization papers. (Photograph courtesy of the Milwaukee Jewish Historical Society.)

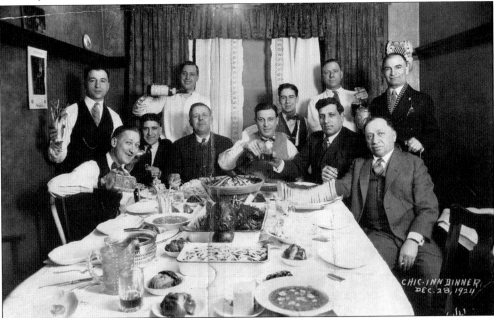

Sometimes, men just like to get together for a good time as the old year ends and a new one looms. This group of businessmen gathered for a "Chic-Inn" dinner on December 28, 1924. (Photograph by Kuhli Studios, courtesy of the Milwaukee Jewish Historical Society.)

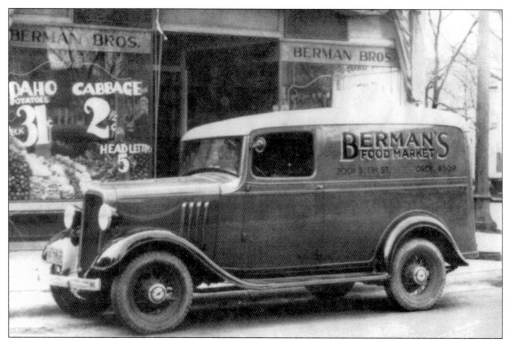

The delivery truck for Berman's Market, on South Thirteenth Street, was a familiar sight around Milwaukee in the days before World War II, hauling produce from Commission Row to the store where a peck of potatoes was only 31¢.

Max Altman was the proud proprietor of a clothing store on South Third Street, seen here in 1928. In the back of his shop, tailors were on hand to take care of any alterations. (Photographs courtesy of the Milwaukee Jewish Historical Society.)

In the early 1930s, Ruth Rubin was behind the counter while a helper carried produce at Esther and Adolph Haudy's Fruit Market, on Twenty-sixth Street and North Avenue. The market remained in operation until the early 1950s when business was shifted to Tenth and Reservoir Streets. (Photographs courtesy of the Milwaukee Jewish Historical Society.)

Luber's Fruit Market, 2269 South Howell Avenue, was a longtime south side fixture. Seen at the store in 1933 are (second and third from left) Joe Bornstein and Alex Messauk. Kate Luber is at the far right. The others are unidentified.

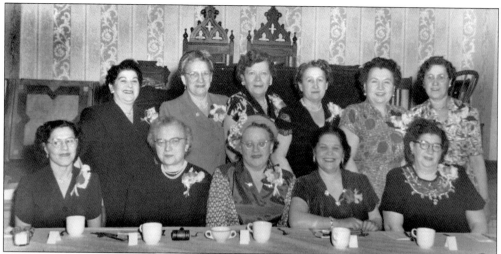

The Ladies Auxiliary of the Milwaukee Fruit Peddlers Union always had a grand time when they met for lunch and kibbutzing in the 1930s and 1940s. Pictured from left to right are: (first row) Mary Kramsky Atinsky, unidentified, Ceil Feller, Norma Glick, and Bessie Bocksenbaum; (second row) Lena Kassoff, Ethel Zavik, Rose Polsky, Rose Namerofsky, Eda Schumacher, and Frieda Sokol. (Photograph courtesy of the Milwaukee Jewish Historical Society.)

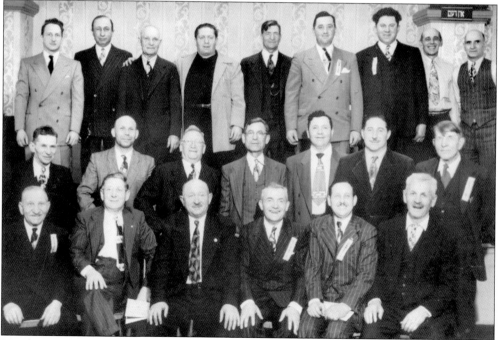

Members of the Milwaukee Fruit Peddlers Union gathered for a meeting just before World War II. Among them along the third row were Abe Chudnow (far left), Morris Marks (third from left). Isadore Petterman, Nathan Goldberg, and Sam Eichenbaum are fifth, sixth, and seventh from left. In the second row were Mr. Weicher (far left), Louis Schumacher (third from left), and Rubin Atinsky (second from right). Seated were Max Chudnow (far left), Sam Lofchie (third from left), Louis Rudack (second from right), and Harry Siegel (far right). (Photograph courtesy of Mary Kramsky Atinsky and the Milwaukee Jewish Historical Society.)

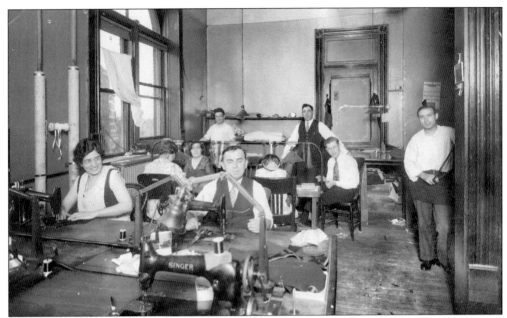

From 1925 through 1955, Hianny's Vest Shop was located on the fourth floor of the Miller Building, 111 East Wisconsin Avenue. This photograph dates from around 1933. The building was razed in 1955. Behind their machines in the front were Frances Zinnokur and Benny Glick. Behind them were Mary Azorella, seated in front of Sam Letizia. Ted Warshaski was in front of Oscar Hianny. Standing at the far right was Lester Heiny. In 1912, Hianny emigrated to the United States and soon launched his vest-making firm. (Photograph courtesy of the Milwaukee Jewish Historical Society.)

Junior House was founded by William J. Feldstein (right) and Sol Rosenberg (left) in 1945. The company, which later became J. H. Collectibles, was one of the country's most successful manufacturers of junior sportswear and dresses. Teen House, a subsidiary building, was on First and Scott Streets, while the company's primary offices were at 805 South Fifth Street. Feldstein was also on the national board of the State of Israel Bonds and the American Committee for the Weizmann Institute of Science. In 1968, he was elected "Manufacturer of the Year" by the Apparel Manufacturers of America. (Photograph by Kuhli Studios, courtesy of the Milwaukee Jewish Historical Society.)

Florence Eiseman was a nationally-known clothing designer and manufacturer who began sewing smocks as gifts. Her hobby turned into a business in 1945, when her husband, Laurence, secured an order of pinafores from Marshall Field's. In the mid-1950s, her sons Laurence Jr. and Robert expanded the lines to include boys clothing. In 1990, the company was sold to several Milwaukee investors. (Photograph courtesy of the Milwaukee Jewish Historical Society.)

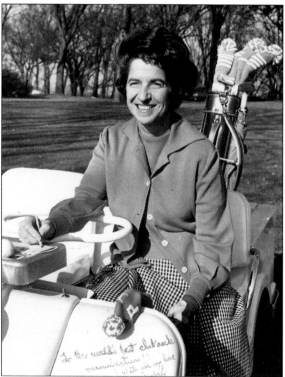

Isabelle Polacheck became head of Reliable Knitting Mills after her husband died in 1972. The business was founded in 1911 by her father, Armin Rosenberg, and his brother Sam. A third brother Ben was also involved in the company. Joe, a fourth brother who lived in Los Angeles, was the firm's banker. Another of his clients was the Disney Corporation. The brothers were born in Hungary, first settling in Cleveland before coming to Milwaukee. (Photograph courtesy of Barbara Blutstein.)

With his older brother, Harold, Bernard J. Sampson established a business development firm that contributed to Milwaukee's economic revitalization from the 1960s through the 1980s. (Photograph by Meryl Olsen, courtesy of the *Wisconsin Jewish Chronicle*.)

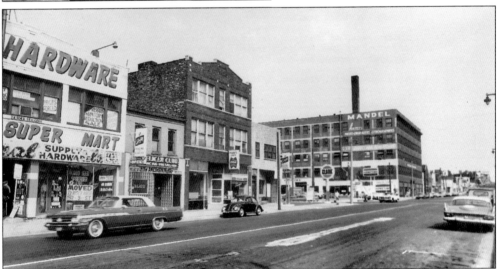

In 1949, Marshall Rotter started selling hardware and Army surplus to farmers out of a pickup truck while his wife, Sammie, worked in a small hardware store in downtown Waukesha. In 1950, Rotter opened a hardware outlet on Juneau Avenue and a short time later moved to the 1200 block of Third Street. He was there until 1966 when the building was acquired for the Park East freeway. Rotter subsequently moved to 1317 North Third Street and then shifted to the company's current location at 1303 North Fourth Street in 1987 and had four other stores throughout Milwaukee. Rotter's sons Bill and Dave also entered the family business. The company joined Ace Hardware in 1990. (Photograph courtesy of the Rotter family.)

George Bockl has remained an inveterate author, even into his 90s, writing on topics as diverse as real estate to spiritual rebirth. Born in Russia, he witnessed the Bolshevik Revolution firsthand and escaped to America when he was 12 years old. He started his own realty company and was instrumental in helping many African Americans find affordable housing in the 1960s. Pushing the notion of "enlightened capitalism," his book, *How Real Estate Fortunes Are Made,* sold 300,000 copies. (Photograph courtesy of George Bockl Enterprises.)

Here is the fascinating, step-by-step account of how one man, starting with very little money, made a fortune in local real estate deals.

How to Use Leverage to Make Money in Local Real Estate

GEORGE BOCKL

In this book you'll discover how you, too, can acquire a fortune *without leaving your local community.* It shows you how to spot, acquire, and sell properties with hidden profit potential using an unusual technique called "Leverage."

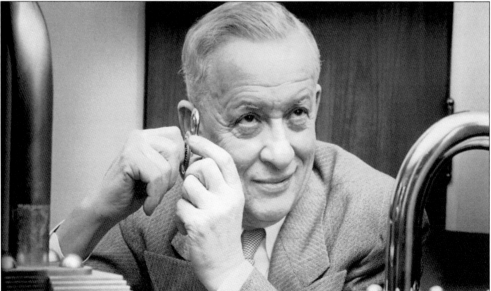

Harry Soref invented the laminated steel padlock and formed the Master Lock Company, which eventually became the world's largest padlock manufacturer. In 1928, the firm provided 147,600 locks to federal prohibition agents for securing closed speakeasies. The Soref Community Services Building at the Jewish Community Center is named in his honor. (Photograph courtesy of Master Lock Company.)

Elmer Winter (left) and his brother-in-law Aaron Scheinfeld, opened the nation's first temporary employment service in 1948 as a sideline to their law practice. In 1977, the company was sold and Winter retired. At the request of the late Prime Minister Yitzhak Rabin in 1976, Winter formed the Committee for Economic Growth of Israel (CEGI) to encourage joint ventures with Israeli concerns. He was also an honorary national president of the American Jewish Committee. (Photograph courtesy of Manpower Incorporated.)

Larry Chudnow talked with contractors at the old Chudnow Iron and Metal Company Incorporated, on State Street. The firm started as a small scrap metal firm founded by Chudnow's grandfather Max who headed the Milwaukee Peddlers Union for 35 years. Max Chudnow came from Russia prior to World War I. He and his wife, Sarah, had seven children, emphasizing to them the practice of *tzedakah*, or charitable giving. (Photograph courtesy of Richard Chudnow.)

Seven

THE PROFESSIONAL WORLD

Milwaukee's Jewish men and women have made their names in many fields, both at home and away. The city's first Jewish physician was Dr. Charles C. Shoyer, who set up practice in 1851. He was followed in 1862 by Dr. Louis Adler, who had been trained in Vienna. Harry A. Waisman was a highly regarded researcher at the University of Wisconsin, where the Waisman Center on Mental Retardation and Human Development was named in his honor. Computer expert and scientist Herbert Simon, a professor at Carnegie Mellon University, won the Nobel Prize for economics in 1978.

The first Jew to be admitted to the bar in Milwaukee was Nathan Pereles, a Bohemian who came to America in 1845 at the age of 21. He began practicing law in 1857 and by the 1860s had an extensive practice. William B. Rubin (1873–1959) and Joseph A. Padway (1890–1947) were well-known civil libertarian lawyers and vigorous defenders of unionism and socialism. Attorney Charles L. Aarons was elected judge of the Milwaukee County Circuit Court in 1925, 1931, 1937, and 1943. Milwaukee-born Abner Mikva became a judge on the United States Circuit Court of Appeals in 1979 and was White House counsel under President Bill Clinton in the mid-1990s.

Bernard A. Abrams (1847–1920) was an assistant superintendent of schools in the 1880s. Baruch Schleisinger-Weil represented Milwaukee in the State Assembly in the 1850s, and Samuel Rindskopf was recording secretary of the Republican club in the 1870s. Henry Meissner was chairman of the Milwaukee County Chapter of the Red Cross after World War I and was a 24-year veteran of the Milwaukee School Board. The list of accomplished Jewish Milwaukeeans goes on and on and on.

Victor Louis Berger (1860–1929) helped found the Milwaukee Social Democratic (Socialist) Party. Born in Austria-Hungary, Berger emigrated to Milwaukee and became the first Socialist member of the United States Congress. He served from 1911 to 1915 and from 1921 to 1929. During World War I, Berger was sentenced to prison under the Espionage Act for opposing the war. In 1918, Congress used this fact to refuse seating to Berger, who had just been reelected by the state's Fifth Congressional District. In 1919, Berger was exonerated and served in Congress until his death in 1929.

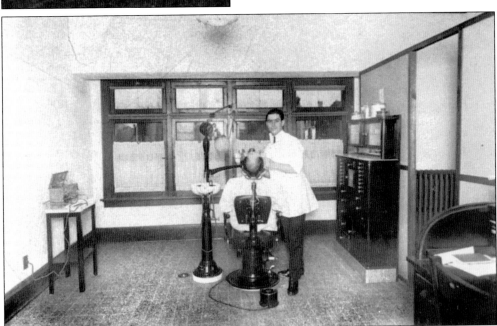

Dr. Harold W. Friedman was a graduate of the Marquette University Dental School in 1925, whose offices were at Twenty-seventh Street and Fond du Lac Avenue. Friedman's widow, Minnie, was a longtime volunteer for Jewish causes and founded a Junior Hadassah group at age 17. For her work on behalf of Israel Bonds, she received the Golda Meir Award and Gates of Jerusalem Medal in 1991. (Photographs courtesy of the Milwaukee Jewish Historical Society.)

Milwaukee's first Jewish policeman, Emil Hansher, served on the force in the 1920s. His brother Joseph the city's first fireman, is seen here in 1909 on the running board of a department hose wagon. He was also a pipeman on the fire boat, the *Torrent*. The Hanshers came to Milwaukee from Poland in 1893. Joseph joined the fire department in 1907 and served for 25 years. In 1909, he helped fight one of Milwaukee's major historical blazes when the old Johns-Manville factory was destroyed. Six firefighters died in that conflagration and 12 were injured. He died in 1955. (Photographs courtesy of the Milwaukee Jewish Historical Society.)

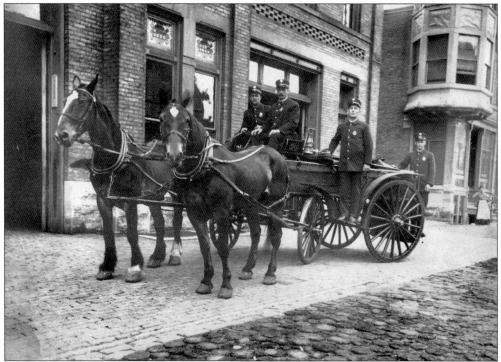

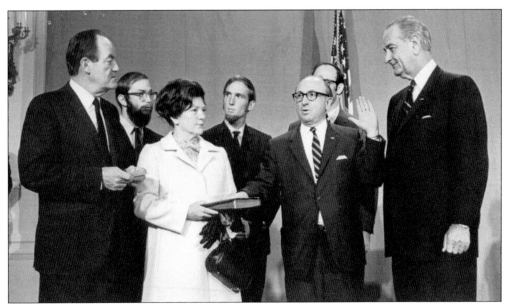

Milwaukeean Wilbur Cohen was sworn in as secretary of the Department of Health and Human Services in 1968 as President Johnson (right) looked on. They were joined by Vice-President Hubert Humphrey (left) and Cohen's wife and three sons. Earlier, Cohen was a staffer for the Committee on Economic Security (CES) that drafted President Roosevelt's Social Security proposal. He became the first employee of the Social Security Board as the agency's chief liaison to Capitol Hill. Cohen, a University of Wisconsin graduate, also became dean of the University of Michigan School of Education. Born in 1913, he died in 1987 while on a speaking engagement in South Korea. (Photograph courtesy of the Social Security Administration History Archives.)

Born in Milwaukee, Walter H. Annenberg was the sixth of eight children by Sarah and Moses (Moe) Annenberg. The elder Annenberg established a newspaper distribution company and became circulation director for the Hearst Publications. The elder Annenberg then purchased the *Philadelphia Inquirer*. After his father's death, young Walter expanded the family media empire, creating *TV Guide* and *Seventeen* magazine. It is estimated that he donated more than $2 billion to numerous charities. In 1969, Annenberg was appointed ambassador to Great Britain. (Photograph by Douglas Kirkland, courtesy of the Annenberg Foundation.)

Milwaukeean Newton Minow was appointed chairman of the Federal Communications Commission by President John F. Kennedy in 1961. After serving in World War II, he became a Supreme Court law clerk and played a major role in Adlai Stevenson's presidential campaigns in 1952 and 1956. Minow is most noted for his critical look at the broadcast industry, once saying, "Television is a vast wasteland." He currently is senior counsel to the law firm of Sidley Austin Brown & Wood, LLP, in Chicago. (Photograph courtesy of Sidley Austin Brown & Wood LLP.)

Helen Bader founded the Milwaukee Institute on Aging and the Environment in the University of Wisconsin-Milwaukee School of Architecture and Urban Planning. The Helen Bader School of Social Welfare at UWM continues to train students in social work and criminal justice. In her name, UWM developed the Helen Bader Institute for Nonprofit Management. (Photograph courtesy of the Milwaukee Jewish Historical Society.)

Myron L. Gordon was a Milwaukee County Civil Court judge from 1950 to 1954 and a Milwaukee County Circuit Court judge from 1954 to 1961. He was elected to the Wisconsin Supreme Court in 1961 and served until 1967, when President Lyndon B. Johnson appointed him federal district court judge for the Eastern District of Wisconsin. In 1983, Gordon became the court's senior judge. (Photograph courtesy of the Milwaukee Jewish Historical Society.)

Attorney Franklyn M. Gimbel is a founding partner of the law firm of Gimbel, Reilly, Guerin & Brown. He served as an assistant United States attorney from 1963 to 1968 and has been president of the Milwaukee Bar and the State Bar of Wisconsin and chair of the State Bar of Wisconsin Board of Governors. Gimbel was also chairman of the Wisconsin Center District Board and served on the Milwaukee Fire and Police Commission. (Photograph courtesy of Gimbel, Reilly, Guerin & Brown.)

Attorney Robert Habush heads the firm of Habush Habush & Rottier, S.C., with 11 offices throughout Wisconsin. Active in numerous law organizations, he is a Fellow of the International Academy of Trial Lawyers, where he serves on the board of directors. Habush has won numerous awards for his charitable work and for Jewish causes. (Photograph courtesy of Habush Habush & Rottier, S.C.)

Noted art patron Esther Leah Ritz was president of the Harry & Rose Samson Family Jewish Community Center from 1966 to 1971. When she was elected president of the Milwaukee Jewish Federation in 1978, Ritz became one of the first women in the country to hold such a position. She also served as president of the JCC Association-Florence G. Heller Research Center and chaired the World Confederation of JCCs. (Photograph courtesy of the Milwaukee Jewish Historical Society.)

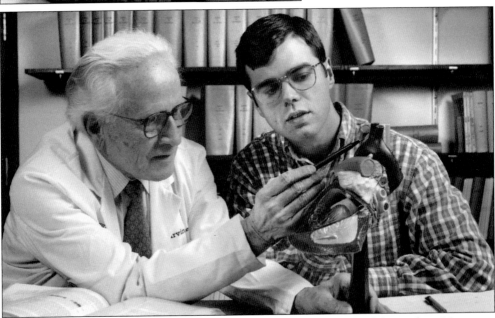

Dr. Marvin Wagner was born in Milwaukee in 1919, receiving his medical degree from Marquette University, with his residency at Mount Sinai Medical Center in Milwaukee from 1944 to 1946, before entering the Army Medical Corps. He returned to Sinai with senior surgical status. From 1950 to the present, Wagner has been a clinical professor of surgery and anatomy at the Medical College of Wisconsin. (Photograph courtesy of the Medical College of Wisconsin.)

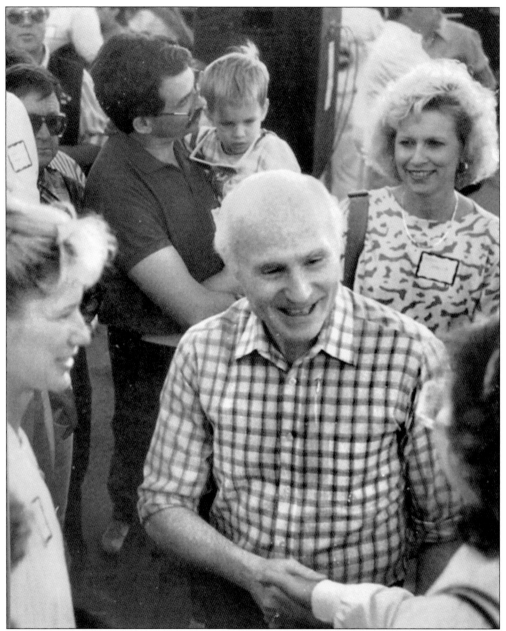

Senator Herbert H. (Herb) Kohl was born February 7, 1935, in Milwaukee where he attended public school. He is currently the senior senator from Wisconsin and a leader in the Wisconsin Democratic Party. He earned a master's degree in business administration from Harvard University in 1958. Kohl has been recognized as a strong advocate for children's issues and serves on the Senate Appropriations Committee, the Judiciary Committee, and the Special Committee on Aging. He is the ranking member of the Agriculture Appropriations Subcommittee. Before coming to the Senate, Kohl helped build his family-owned Kohl's grocery and department stores, acting as president from 1970 through the sale of the corporation in 1979. In 1985, he bought the Milwaukee Bucks basketball team. In addition to his many other charities, Kohl donated $25 million to UW-Madison for a sports arena. (Photograph courtesy of Senator Herb Kohl.)

Norman Gill was the first president of the Bureau of Jewish Education when it was formed in 1944 and became executive director of the Citizens Governmental Research Bureau (now called the Public Policy Forum) in 1945. The bureau was formed in 1913 to promote systematic methods of managing and supervising municipal operations. (Photograph courtesy of the Milwaukee Jewish Historical Society.)

Mordecai Lee was elected to the State Assembly in 1976, 1978, and 1980, representing Milwaukee's Sherman Park area. He was then elected state senator from Milwaukee's northwest side in 1982 and reelected in 1986. While in office, he chaired the Senate's Environmental Resources Committee and was named one of "Wisconsin's Ten Best Legislators" by *Milwaukee Magazine*. In 1990, Lee was named executive director of the Milwaukee Jewish Council for Community Relations and then became an associate professor of governmental affairs at the University of Wisconsin-Milwaukee. (Photograph courtesy of the *Wisconsin Jewish Chronicle*.)

Eight

CELEBRATING
THE HOMELAND

Keeping in touch with both a spiritual and physical homeland has long been a driving force within the Milwaukee Jewish community. The Jewish Federation lists numerous organizations that retain that connection. Among them are the American Friends of the Hebrew University—Midwest Chapter; Americans for Peace Now—Wisconsin Chapter; Committee For Economic Growth of Israel (CEGI); Development Corporation for Israel/Israel Bonds; Israel Center Community Shaliach From Israel; Jewish National Fund; Magen David Adom U.S.A.; Parents of North American Israelis (PNAI); Partnership 2000; Passport to Israel Program; and the Zionist Organizations of America—Milwaukee District (ZOA).

The ZOA was founded in 1897, working to maintain American Jewry's commitment to Zionism and the State of Israel. The Milwaukee ZOA district joins the national organization in forging a bond with the people of Israel and with other Jewish communities around the world. ZOA sponsors the Masada high school and college groups. Both the Zionist and Socialist movements prior to World War I in Milwaukee, as they did elsewhere, helped introduce the Jews into revolutionary movements that helped shape history.

Over the years, Milwaukee's Jews have contributed tens of millions of dollars to support educational, political, artistic, social, and charitable causes in Israel. Trees have been planted, dams built, museums constructed and schools opened with the help of the Milwaukeeans. Many local personalities have taken leading roles on a national and international level in raising funds for these many causes.

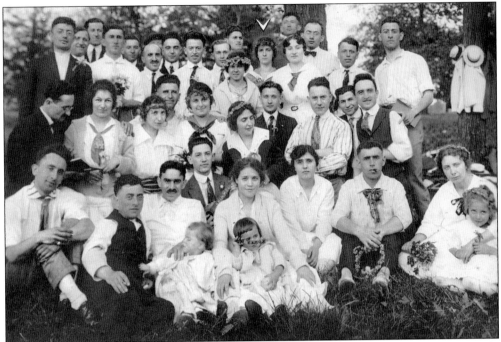

Activists in Milwaukee's Labor Zionist movement gathered on July 4, 1917, for a picnic in Lincoln Park. The arrow in the center points out young Golda Mabovitch and her future husband Morris Myerson. The woman on the far right with the little girl in her lap is Mabovitch's married sister Sheyna. Mabovitch and Myerson were married that December and moved to Palestine. Although they eventually separated, the couple remained friends and Myerson died in 1952 in Meir's home. Golda used the Hebrew name, "Meir," meaning "that which gives light." (Photograph courtesy of Harry Perlstein and the Milwaukee Jewish Historical Society.)

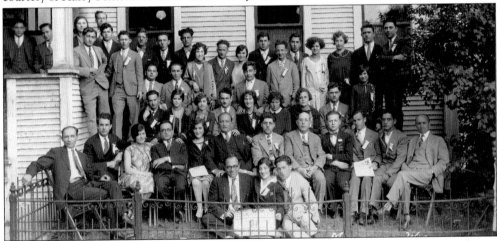

Delegates to the Seventh annual Young Poale Zion Convention, August 31 to September 3, 1928, gathered in Milwaukee, meeting at the Jewish Folk Institute. Representing Milwaukee were George Teplinsky and Yetta Pickman. A banquet in Milwaukee's Republican Hotel concluded the conference. Local organizers included Sadie Pickman, Milton Shapiro, Oscar Roitblatt, Sol Shoob, Bernard Rabinowitz, and Fannie Shoor. (Photograph courtesy of Fannie Zilber Kesselman and the Milwaukee Jewish Historical Society.)

Abraham J. Kamioner (fourth row, second from left) attended a conference of Zionist organizations in Havana, Cuba, in November 1941. He was the uncle of Milwaukeean Betty Hornek, who provided documentation and photographs of the event to the Milwaukee Jewish Historical Society. (Photograph courtesy of Betty Hornek and the Milwaukee Jewish Historical Society.)

Boating across the Sea of Galilee in 1948, Milwaukee newspaperman Irving Rhodes was guarded by a woman from the Haganah. Rhodes, publisher and cofounder of the *Wisconsin Jewish Chronicle*, led a delegation of American Jews from the United Jewish Appeal. The *Wisconsin Jewish Chronicle* was established in 1921, with Rhodes as business manager, Nathan J. Gould as publisher and editor, and Maurice M. Safir as advertising manager. Rhodes was born Israel Gedaliah Rosenstein in 1900 and died in 1977. The award-winning *Wisconsin Jewish Chronicle* is currently published by the Milwaukee Jewish Federation, which bought the paper in 1972. (Photograph courtesy of the Milwaukee Jewish Historical Society.)

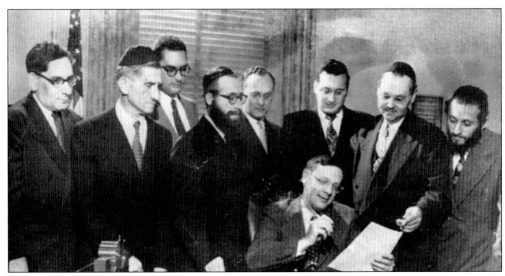

As a preliminary to the launching of Israel Bond Month in 1952, Mayor Frank Zeidler issued a statement supporting the campaign. With him in City Hall were, from left to right: (first row) Rabbis David Shapiro (Anshe Sfard), David Becker (Congregation B'nai Jacob), Israel Feldman (Agudas Achim), Mayor Zeidler, Harold Baumrind (Congregation Beth Israel), and Abraham Twerski (Beth Jehudah, assistant rabbi); (second row) Rabbis Herbert Friedman (Congregation Emanu-El B'ne Jeshurun), Harry Pastor (Congregation Shalom), and Paul S. Greenman (United Synagogue B'nai Sholom). Unable to be present at the ceremony were Rabbis Louis Swichkow (Beth El Ner Tamid), and Solomon Schulson (Congregation Anshai Lebawitz), who also participated in the drive. (Photograph courtesy of Congregation Shalom.)

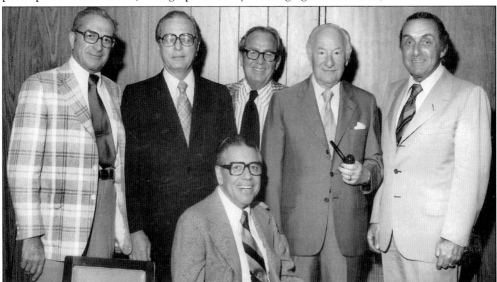

William J. Feldstein met with other Israel Bonds leaders planning an all-city dinner in his honor in 1965. The committee included, from left to right, Philip Rubenstein (executive committee member), Max H. Karl (president of the Bonds Prime Ministers' Club), Benjamin J. Free (general chairman of Israel Bonds for Wisconsin), Ben D. Marcus (special sales), and Gerald S. Colburn (associate chairman of Israel Bonds and chairman for the Feldstein dinner). (Photograph by Andrei Lovinescu, courtesy of the *Wisconsin Jewish Chronicle*.)

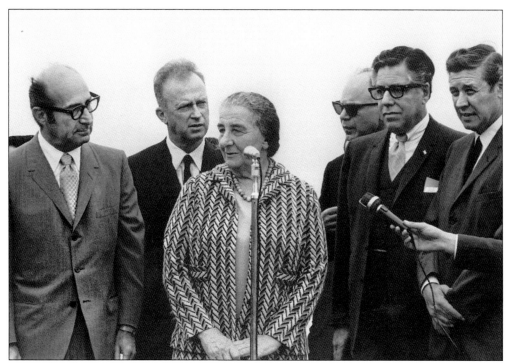

Local dignitaries greeted Israeli Prime Minister Golda Meir when she visited Milwaukee on October 3, 1969. At an airport press conference, Meir was joined by, from left to right, Albert (Ollie) Adelman, Yitzhak Rabin, Mel Zaret, Bill Feldstein, and Mayor Henry Maier.

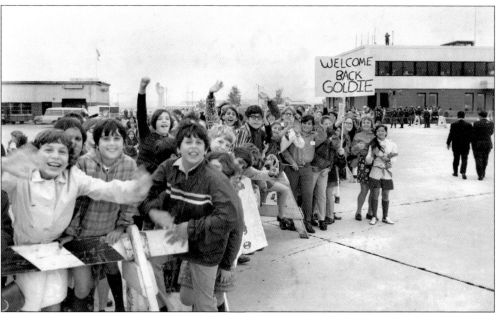

Milwaukee schoolchildren applauded Israeli Prime Minister Golda Meir during her visit in 1969. Charming her hometown at numerous functions, Meir also dropped by her old north side neighborhood. (Photographs courtesy of the Milwaukee Jewish Historical Society.)

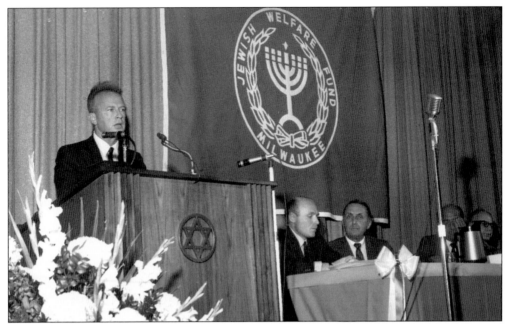

Yitzhak Rabin (speaking) visited Milwaukee for the annual Jewish Welfare Fund fund drive in 1968. With him during his speech were, from left to right, Herb Kohl, Jerry Colburn, Albert Adelman, and Mel Zaret. After serving in many governmental capacities, Rabin became the country's prime minister in 1992. He was assassinated in 1995. (Photograph courtesy of the Milwaukee Jewish Historical Society.)

In 1969, Louise Eder made the first of her 28 visits to Israel as a member of the Women's Division Mission of the United Jewish Appeal. As a national board member of the American Jewish Joint Distribution Committee, she also traveled widely elsewhere. A native of Illinois, Eder moved to Milwaukee in 1958 with her husband, Ralph, a manufacturing entrepreneur. She died in 2001. (Photograph courtesy the Milwaukee Jewish Historical Society.)

State of Israel Bonds dinners always attracted many charitable activists. This program on September 29, 1963, was attended by, from left to right, unidentified, Norton Siegel, unidentified, Eliot Bernstein, Rabbi Louis Swichkow, Mr. and Mrs. Nathan Stillerman, Carl Millman, Ben Chudnow, Abe Chudnow, Lena Druck, and Charles Lubotsky. (Photograph courtesy of the Milwaukee Jewish Historical Society.)

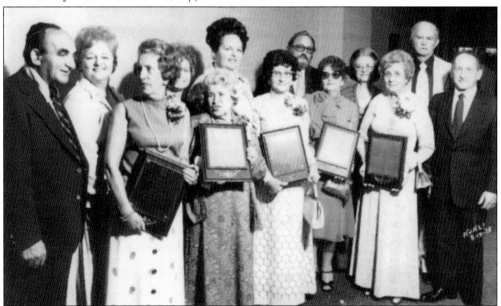

Honored at a JNF dinner in 1975 were the Five Milwaukee Women of Valor. Pictured from left to right are: (first row) Jeanette Swed, Minnie Cornfield, Rebbetzin Lea Twerski, Goldie Sosoff, and Dorothy Lubotsky; (second row) Yaacov Morris, Mrs. Stanley Holland, Mrs. Ervin Chudnow, Mrs. Larry Weidenbaum, Jack Lerman, Mrs. Jack Rabinovitz, JNF regional director Eli Shwartz, and JNF president Avrum Chudnow. (Photograph courtesy of the *Wisconsin Jewish Chronicle*.)

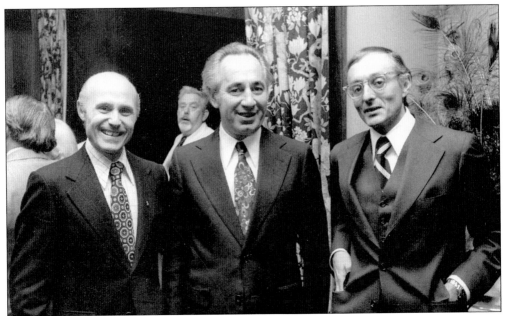

Herb Kohl (left) and Sheldon Lubar (right) met with Shimon Peres during the Israeli leader's visit to Milwaukee around 1978 as part of a Jewish Federation fund-raising event. Peres became a member of the Knesset in 1959 and was Minister of Defense from 1974 to 1977, serving as prime minister from 1984 to 1986.

In 1989, Milwaukee Jewish Federation tour members in Israel recited *Shehechyanu*, a blessing recited on joyous occasions. The group included Todd Lappin, Sylvia Bernstein, David Raz, and Larry Gellman. (Photographs courtesy of the Milwaukee Jewish Historical Society.)

Milwaukeean Jerry Benjamin visited a young Ethiopian immigrant in her gas mask, during a trip to Israel at the height of the first Gulf War in 1991. Benjamin, of the United Jewish Appeal's Young Leadership Cabinet, toured the Mavasseret Zion Absorption Center near Jerusalem. He became vice president of the Milwaukee Jewish Federation's Israel and Overseas Committee. (Photograph by Robert A. Cumins, courtesy of the UJA Press Service and the *Wisconsin Jewish Chronicle*.)

Graham Hoffman, 16, of Milwaukee, sailed from Brindisi, Italy, to Haifa, Israel, in a 1995 recreation of the 1947 *Exodus* voyage as part of an Israel Experience program supported by the Jewish Federation. Such programs are administered by the Jewish Agency for Israel, to help youngsters develop an emotional attachment to Israel. (Photograph by Sammy Avnisan, courtesy of the UJA Press Service and the *Wisconsin Jewish Chronicle*.)

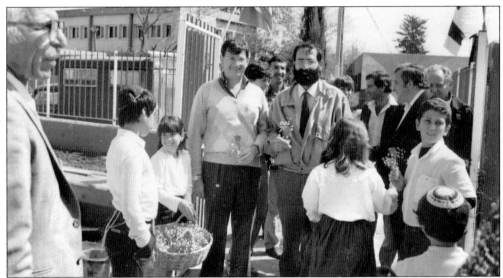

Milwaukeean Allen Samson, executive vice president and CEO of American Medical Services, walked with the mayor of Or Yehuda, Israel, during a Project Renewal visit. Samson was the first American to win the Kaplan Prize for his work rebuilding the town near Tel Aviv. Milwaukee's involvement with the project began in 1977 and Or Yehuda became a Milwaukee Jewish Federation sister city in 1978. Other locals visiting the town have included Judy Gordon, Bruce Arbit, Jerry Benjamin, and Flo Minkoff. (Photograph courtesy of the Milwaukee Jewish Historical Society.)

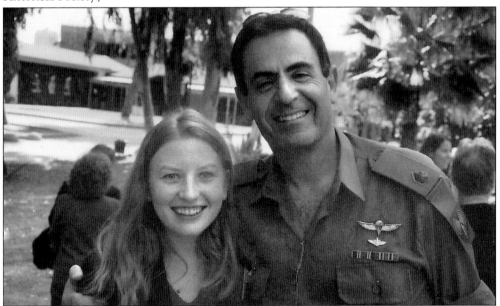

Milwaukee Hillel student Shanna Shapiro met Jonathan Davis, reserve officer from the Israel Defense Force Spokesman's Office and vice president for external relations at the Interdisciplinary Center (IDC) in Herzliya, during the Milwaukee Jewish Federation Partnership Mission to Israel in November 2003. Shapiro, studying marketing at the IDC, was one of three students with ties to Hillel Foundation-Milwaukee in Israel that year. (Photograph courtesy of the *Wisconsin Jewish Chronicle*.)

Nine

ALL THE FUN WITH SPORTS, ARTS

The Abraham Lincoln House at the Lapham Park Social Center was a fixture of the neighborhood around Ninth and Vine Streets from 1908 to 1936. The facility hosted numerous meetings for arts, political, and social groups which found a home there. There were eight rooms on the second floor that rotated meetings at 7:00, 8:00, and 9:00 p.m. every night except Friday, Saturday, and Sunday. These clubs often fielded sports teams. When the building closed at 10:30 p.m., the streets flooded with people who hung around talking and flirting.

Milwaukee athletes with a Jewish heritage included champion golfer Vicki Zimmerman of Shorewood who won the Wisconsin Women's Golf Association title in 1971 and 1974. Other stars include Gary Adelman, state junior tennis champ in 1958 and rated number one the following year by the Wisconsin Lawn Tennis Association; Susan Halloway, the 1973 National Collegiate bowling champion; and speed skater Angela Zuckerman, a member of the United States Olympic Team in the 1990s. Max Shimon was a noted Milwaukee billiards player, bowler, and golfer. He held the national amateur three-cushion billiards championship in 1926 and 1927 and had 28 holes-in-one, which was the third highest total in the nation when he died in 1972.

The arts and cultural scene have always been important. Noted composer and organist Max Jankowski (1912–1991) directed the Congregation Shalom Adult Choir in 1953 and 1954. Pianists Arthur Rubenstein and Peter Serkin, comics Gabe Kaplan and Jack Benny, actor Dennis Morgan, and numerous other Jewish performers played the Pabst Theater stage. For many years in the 1870s and 1880s, the theater's business manager was the Berlin-born Siegmund Selig. The Milwaukee Jewish Community Chorale was established in 1994.

For readers, the North Shore Library in Glendale has one of the area's largest collections of Judaica. Within the Jewish theater world, familiar names such as Harry Perlstein, Howard Weinshel, Bess Lerner, Ruth Stein, Gertrude Tepper, Isadore Tepper, Jerry Tepper, Paula Peltz, Norman Tugenberg, Henry Lerner, Leo Musickant, Judd Post, and Paul Melrood have appeared over the years.

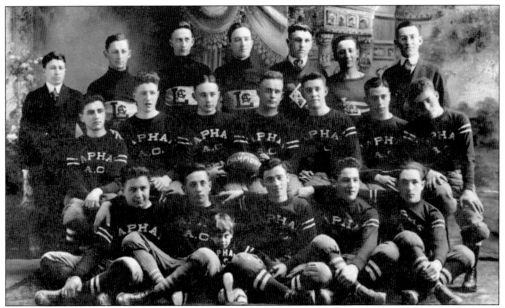

The Lapham Park Athletic Club football team in 1914 fielded such local heroes as Harry Zaidens (standing, far left) and Sid Geisenfeld (third from right), with coach Manny Wolf at the far right. Seated was Dr. C. Waisbren on the far left. The others are unidentified.

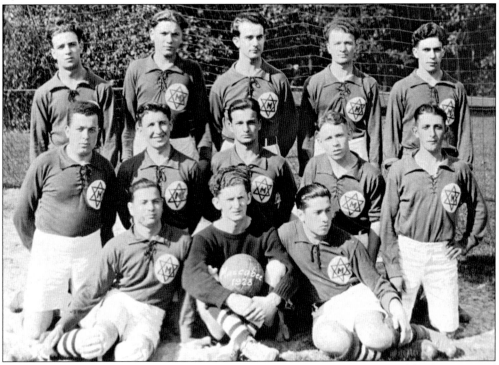

The Maccabees soccer team was ready for action in 1928, playing against clubs from around the city. It was one of many sports teams fielded by Jewish athletes who were star players in high school, college, and on the amateur level. (Photographs courtesy of the Milwaukee Jewish Historical Society.)

All-American Albert (Ollie) Adelman, wearing the number 36 jersey for Northwestern University, smashed through the Notre Dame line in a 1935 game. Also a stellar tennis player, Adelman is included in the Northwestern University Athletic Hall of Fame, the Wisconsin Sports Hall of Fame, and the Jewish Athletic Hall of Fame. After graduating, Adelman helped his father, Ben, in his laundry business and eventually took over as president and CEO. He grew the small laundry into the nation's largest family-owned dry cleaners. Adelman is now chairman of Adelman Travel, the country's eighth largest travel firm. His 2004 book, *All Things Are Possible*, tells about his growing-up years in Milwaukee and his business operations. (Photograph courtesy of Albert Adelman.)

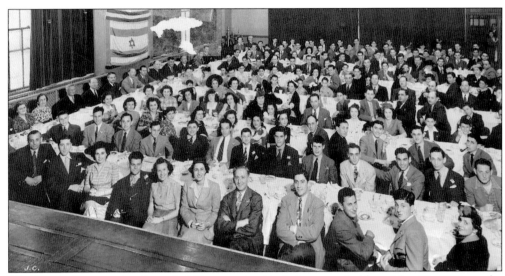

The Jewish Community Center's fifth annual athletic banquet, held on May 28, 1942, at the Milwaukee Street Gym, attracted notable athletes and their families. Pictured from left to right are: (at the speakers' table) Rose Zeid (secretary), Mrs. Bloch (receptionist), Max Karger (board member), George Peizer (executive director), Eugene Mahler (JCC president), Dr. Sid Silbar (physical education chairman), unidentified, unidentified, Tom Stidham (Marquette University football coach), unidentified, unidentified, Lou Rosenblum (JCC athletic director), and Moe Geisenfeld (athletic cochairman); (first row) Fred Alefson, Rubin and Dolly Shuckit, Mr. and Mrs. Herb Gronik, Mr. and Mrs. Louis Silverman, Ben Barkin, and three unidentified persons. (Photograph courtesy of the Milwaukee Jewish Historical Society.)

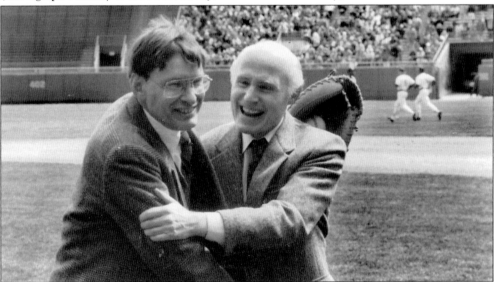

Milwaukee's sports czars hugged prior to a Milwaukee Brewers' baseball game at the old Milwaukee County Stadium. Allen H. (Bud) Selig (left), team owner, was greeted by Wisconsin Senator Herb Kohl, owner of the Milwaukee Bucks basketball team. Selig was a Milwaukee car dealer who purchased the Seattle Pilots in 1970 and moved the team to Milwaukee, renaming them the Milwaukee Brewers. Selig was named baseball commissioner in 1998. In 1985, Kohl bought the Bucks to keep them from moving elsewhere. (Photograph courtesy of Senator Herb Kohl.)

Pulitzer Prize-winning author Edna Ferber is one of Wisconsin's most famous literary figures, emphasizing a strong sense of Jewish identity. Ferber first worked for the *Appleton Post Crescent* and then moved on to the *Milwaukee Journal* where she covered the police and court beats. Ferber wrote 12 novels, 11 books of short stories, 6 plays and 2 autobiographies. Among her most noted works were *Giant* and *Showboat*. (Photograph courtesy of the Wisconsin Center for Film and Theater Research.)

From 1925 until his death in 1974, Alter Esselin was one of the city's most prolific poets. Born in Russia, Esselin was imprisoned for revolutionary activities. When he was freed around 1905, he came to the United States. After his poems began appearing in Yiddish newspapers, he adopted the name Alter Esselman, but a typesetting mistake made it "Esselin." He eventually came to Milwaukee to work as a carpenter. In 1955, Esselin received the Harry Kovner Award from the Yiddish Book Council. (Sketch courtesy of the *Wisconsin Jewish Chronicle*.)

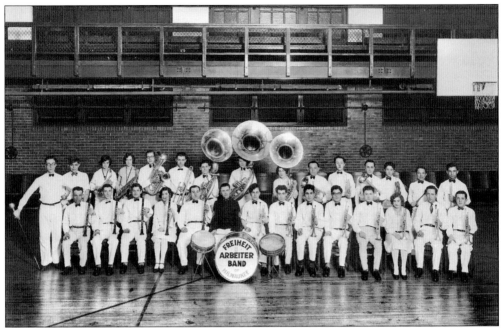

The Freiheit Arbeiter (Freedom Worker) Band attracted numerous young Jewish musicians in 1927. Among them were drum major Larry Katz (far left), first tuba Sol Kosberg, Dorothy Aaron Kianovski, and Selig Weinstein. (Photograph by J. L. Mutzbauer, courtesy of the Milwaukee Jewish Historical Society.)

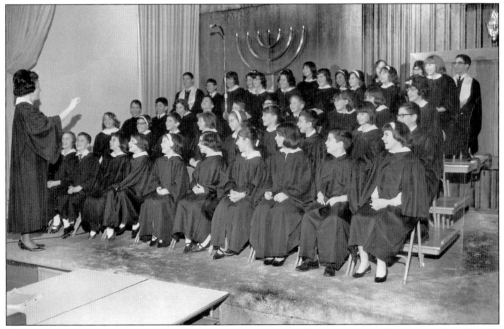

Tybie Taglin, then director of religious school music at Congregation Shalom, led its Youth Choir in a 1965 service. Taglin founded the choir in the 1950s. Taglin wrote an award-winning children's music book called *Shalom Sings* that was distributed nationally. Cantor Karen Berman is the current director. (Photograph courtesy of Max and Tybie Taglin.)

Albert (Ollie) Adelman (left), then president of the Milwaukee Jewish Federation, and his wife, Edie, visited artist Marc Chagall at his home in Nice in the early 1970s. While there, they discussed the design of a tapestry that was eventually placed in Milwaukee's Helfaer Community Service Building. The art piece was subsequently unveiled on April 29, 1973. The tapestry was the gift of retired industrialist Even P. Helfaer, in remembrance of his wife, Marion. (Photograph courtesy of Albert Adelman and the *Wisconsin Jewish Chronicle*.)

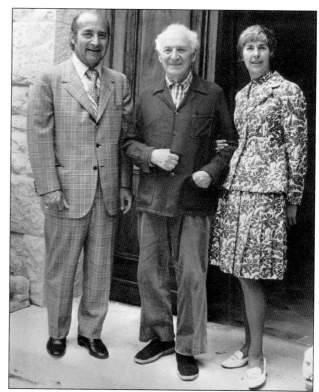

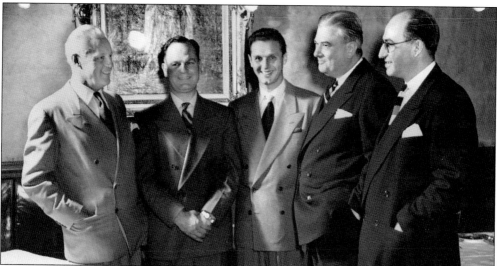

Hollywood writer and producer Cy Howard was a regular visitor to hometown Milwaukee, even when he hit it big in the 1940s and 1950s. Born Seymour Horowitz, Howard produced the radio series *My Friend Irma* and a television show called *Life With Luigi*. In this photograph, Howard (center) met with Harold Fitzgerald (from left), president of Fox Wisconsin Amusement Corporation and chairman of Milwaukee's Civic Progress Commission; alderman/acting mayor Milton J. McGuire, president of the Milwaukee Common Council; federal judge Robert E. Tehan; and Joseph A. Deglman of the Boston Store. (Photograph courtesy of the Milwaukee Jewish Historical Society.)

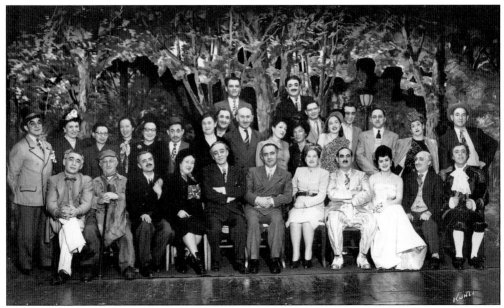

The cast of *Gold* gathered following one of their productions at the Jewish Community Center in 1943. Such works were regularly performed by the Center's Perhift players, which celebrated its 50th anniversary in 1971. At the time, the troupe was the longest running amateur Yiddish theater company in the world, showcasing even well-known actors such as Paul Muni. (Photograph by Kuhl Studios, courtesy of the Milwaukee Jewish Historical Society.)

Isadore Tepper (left) and Harry Perlstein starred in Israel Joshua Singer's *Brothers Ashkenazi*. Both actors appeared regularly with the Peretz Hirshbein Folk Theatre (Perhift Players) at the Jewish Community Center. The Yiddish troupe was formed in Milwaukee in 1920 as the Young Literary and Dramatic Society, which in 1931 became the Yiddish Drama League. (Photograph courtesy of the Milwaukee Jewish Historical Society.)

Milwaukee-born comedian and member of the Wisconsin Performing Artists Hall of Fame, Gene Wilder was born Jerome Silberman in Milwaukee on June 11, 1935. After college and acting school, Wilder appeared on Broadway and made his film debut as an undertaker in *Bonnie and Clyde* in 1967. This photograph is Wilder's 1951 senior class portrait. (Photograph courtesy of Washington High School.)

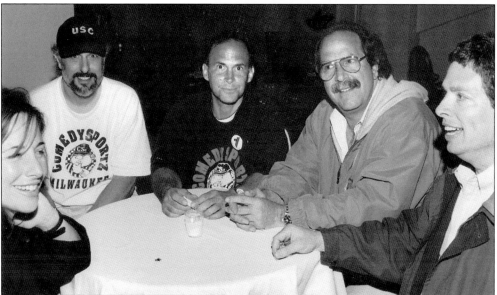

Two friends from Shorewood High School have made their name in show business. David Steinberg (second from right) is an agent for entertainer Robin Williams, while David Zucker (right) works in the film world as a writer and director. Zucker and his brother Jerry are noted for collaborating on popular movie spoofs, such as *Airplane!* (1980) and the *Naked Gun* series. They drop numerous mentions of the city in their films and their parents, Charlotte and Burt Zucker, occasionally make cameo appearances. (Photograph courtesy of Richard Chudnow.)

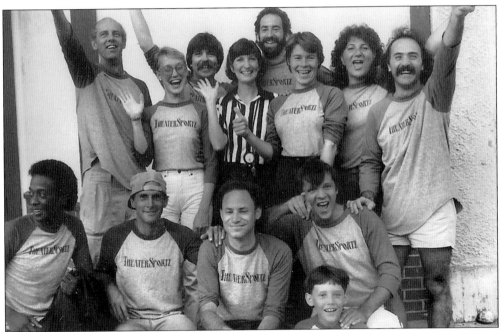

The original cast of Comedy Sportz in 1984 included, from left to right: (first row) Brian Green, Dick Chudnow, Jan Eder, and Bob and Jayke Orvis; (standing in the back) Jon Banck, Nancy Garreet Meyer, John Leicht, Judy and Martin Berkowitz, Karen Koilerq, Rosie Frydman, and Fulvio Paris. The first matches for the improvisation company were held in Kalt's Restaurant on the city's east side. The troupe then had several other homes before settling on a large new home at 420 South First Street. (Photographs courtesy of Richard Chudnow.)

Max Samson, founder and artistic director of the Milwaukee Mask and Puppet Theater, first worked with puppets in 1970. He founded the Heavy Bulky Puppet Theatre in Israel, which toured Europe in 1973. Samson is shown here with his character of Albert Einstein's father, Hermann, in *Einstein: Hero of the Mind*. Samson also worked in the civil rights movement in the South during the 1960s. (Photograph courtesy of the Milwaukee Mask and Puppet Theater.)

Ten

ANSWERING THE CALL TO SERVE

Milwaukee's Jewish community has always been ready to answer the country's call to duty, entering all branches of service both in peacetime and in times of conflict. At least three Jewish citizens died in the Civil War: Nathan Neustadtl, Alexander Metzel, and Jonas Goldsmith. Phillip Horwitz, a veteran of the Mexican War before he came to Milwaukee in 1958, joined the Union Army at age 38. Henry Katz, a grandson of early city resident Isaac Neustadtl, graduated from the United States Naval Academy in 1876 and served in the Navy until 1884.

A few Jewish soldiers from the city volunteered in the Spanish American War, setting the patriotic stage for the thousands who followed. Ukrainian-born Joseph Lubar was one of the first Milwaukeeans drafted into the Army during World War I. He was wounded twice in France, receiving the Purple Heart and the Distinguished Service Medal. Lubar earned his citizenship through the service and eventually went into the wholesale liquor business with family members. At least 2,400 men and women of Jewish heritage were in the military during World War II.

A wall in a basement meeting room at the Milwaukee Jewish Home and Care Center is lined with 32 photographs of those who paid the ultimate sacrifice from World War I up to the 1990s. The names are haunting: Guten, Picus, Dubin, Lichter, Reitman, Miller, Schwartz, Sadoff, and many others. One of the earliest was that of Samuel Apstein, killed October 31, 1918, and now buried in the Meuse Argonne Cemetery. Another is Navy Lt. John Leon Abrams, born March 16, 1940, and killed in action July 13, 1968, while flying his attack helicopter in Vietnam. A banner hanging in the room reads: "In sacred memory of our beloved comrades who have made the supreme sacrifice for our safety and security."

The Jewish War Veterans has more than 200 members in its Department of Wisconsin contingent, many of whom meet regularly at the Jewish Home. The national organization was founded in 1896. Some Jewish veterans in Milwaukee served with other countries, most notably in the Soviet army during World War II before coming to the United States.

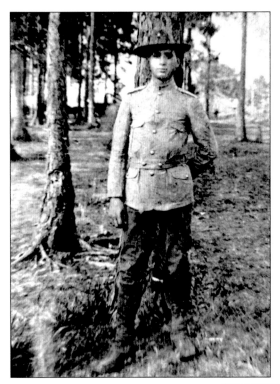

Jacob Frazinsky was a private in Company E, Second Regiment of the Illinois Infantry during the Spanish American War. Frazinsky joined the Army on April 26, 1898, serving for two years. (Photograph courtesy of Sydney Frazin and the Milwaukee Jewish Historical Society.)

Lazarus Rabinovitz, nicknamed "Rothschild" by his buddies, must have given up a lucrative profession to join the army in 1918. When he entered the service, he was called "Milwaukee's richest newspaper boy" by the local media. After the war, he became a member of the Beth El Ner Tamid synagogue, the Zionist Organization of America and the American Legion. (Photograph courtesy of the *Milwauker Wochenblat*, Phyllis Rabinowitz Millman, and the Milwaukee Jewish Historical Society.)

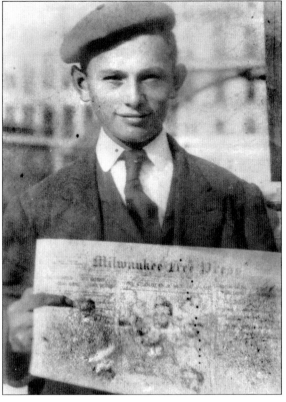

Sergeant Jerry Arbiture served in the First Army from August 1944 through August 1945 and was among the first troops into Nuremberg. From there, Arbiture went on to be among the Allied forces liberating 15,000 British and American prisoners. For Passover in 1945, the military provided matzos for the Jewish troopers, some of which Arbiture took back to his squad after the service. His buddies used them for target practice.

Technical Sergeant Les Bern saw action in the Pacific theater from August 25, 1942, until November 29, 1945. Despite lack of air cover for the landing on Dinagat Island, Bern and his fellow soldiers chased the Japanese enemy through the mountains and destroyed their installations. Bern participated in one wartime seder that was attended by several thousand other Jewish GIs. (Photographs courtesy of *We Were There . . . World War II: The Milwaukee Jewish Experience* and the Milwaukee Jewish Historical Society.)

Lt. Col. Leonard Bessman was one of Milwaukee's most decorated officers during World War II. For heroism in North Africa, Bessman was presented with the Distinguished Service Cross, the Silver Star, Bronze Star, and Purple Heart with clusters. He was a Counter-Intelligence Corps officer in Tunisia. Wounded and captured, he broke out of a prison camp and made his way back to Allied lines. He was well known to noted war correspondent Ernie Pyle, who wrote about Bessman's exploits several times. An attorney before the war, Bessman returned to Wisconsin to practice law after his service. He remained active with the Army Reserve until retiring as a lieutenant colonel. In 1946, Bessman became special attorney for the United States Justice Department's Antitrust Division and was named an assistant attorney general in 1947. He went on to the Wisconsin Public Service Commission and was a bankruptcy judge from 1968 to 1975. (Photograph courtesy of *We Were There . . . World War II: The Milwaukee Jewish Experience* and the Milwaukee Jewish Historical Society.)

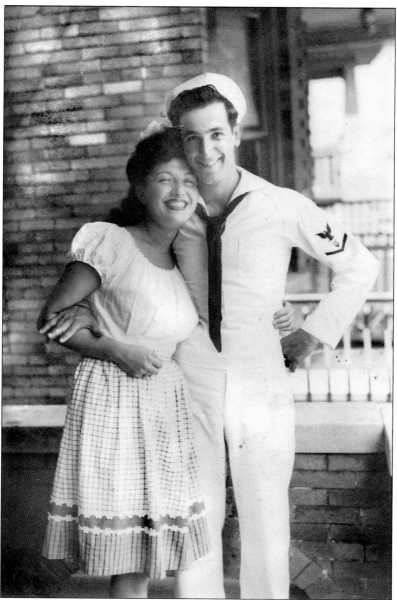

Max and Tybie Taglin enjoyed each other's company during one of Max's leaves from the Navy during World War II. He was a Musician First Class, at the Naval Air Station in Corpus Christi, Texas. The two met at North Division High School when Max was a sophomore trumpet player and Tybie played the piano and flugelhorn in the band. They were attending the old Milwaukee State Teachers College when the war broke out and Max joined the Navy. Max and Tybie were married in 1947 at the Knickerbocker Hotel by Rabbi Louis Swichkow. Tybie went on to be director of cultural arts and events at the Jewish Community Center and Max worked for the Milwaukee County Department of Public Welfare and was executive director of the Jewish Home for the Aged between 1957 and 1967. He became an owner and administrator of Colonial Manor nursing home and founded the Wisconsin Association of Homes Serving the Aging. In the 1980s, they launched Access Milwaukee, a tour business emphasizing Milwaukee and the arts. (Photograph courtesy of Max and Tybie Taglin.)

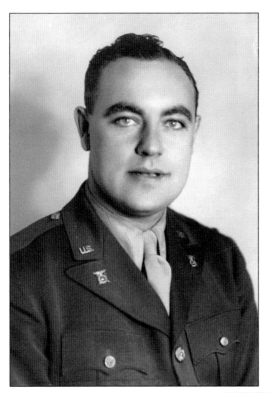

Norman Cohn was born in Chicago on April 4, 1917. Cohn joined the United States Army, earning four battle stars and two bronze stars for his bravery in World War II. After the war, he remained in the Reserves until the 1970s, retiring as a colonel. Cohn took over his father's Waukesha-based water bottling firm in 1948, calling his new firm the Bon Ton Roxo/Bethesda Spring Water Company. He also taught at the Milwaukee Area Technical College and became an active volunteer in Junior Achievement.

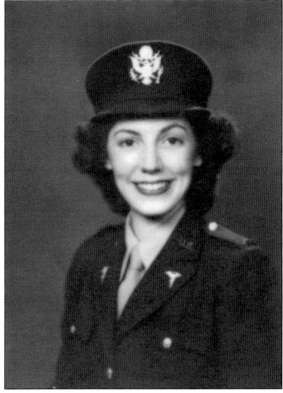

Lucile Mae Kohn, a graduate of the Jewish Hospital School of Nursing in Cincinnati, joined the Army Nurse Corps in December 1944. She was promoted to lieutenant and became a charge nurse for a 1,200 bed mental health hospital. In 1947, she married then Lt. Col. Norman Cohn. The couple moved to the Milwaukee area where her husband worked in his father's water bottling business. Lucile was active in charity affairs and teaching religious classes at Congregation Emanu-El. (Photographs courtesy of the Milwaukee Jewish Historical Society.)

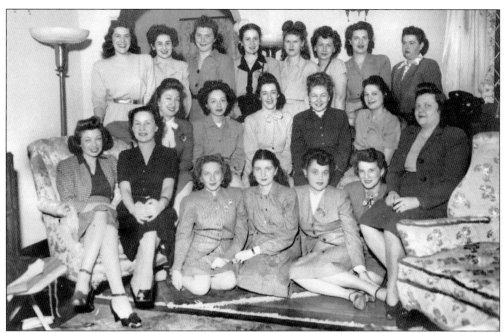

This photograph was taken at one of the first meetings of the Stanley Marsack Auxiliary Post No. 442, Jewish War Veterans of the United States, shortly after it was organized in 1946. The women included: (on the floor, first row) Lala Fishberg, Lenore Swedlow, Rosalind Karp, and Lillian Rakita; (seated, second row) Rosalie Krakow, Esther Padway, Jane Sherkow, Anita Stein, Rochelle Janis, Shirley Belin, Esther Lansky, and Clara Greenberg; (third row) Sara Steren, unidentified, Miriam Kahn, Sara Halperin, Grace Lechter, unidentified, Blanche Margolis, and Shirley Einhorn. (Photograph courtesy of the Milwaukee Jewish Historical Society.)

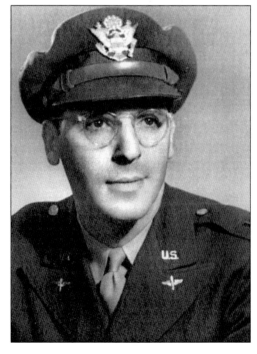

Ohio-born David A. "Bro" Herman moved to Milwaukee in 1939 when he became advertising director of Gimbels. Entering the Army Air Corps, he was on the public relations staffs of General Claire Chennault and General George Stratemeyer, serving in China. After the war, Herman joined forces with Ben Barkin in 1952 to form Barkin, Herman, Solochek & Paulsen public relations agency, with clients such as the Great Circus Parade, the Schlitz Brewery, and the Milwaukee Brewers. Herman and his wife Jean were active in local charities and Jewish causes. Their daughter Mary became the first lady of Maine in 1995 after her husband, Angus King, was elected governor. The Hermans also had two sons: Tom, an attorney, and John, a psychiatrist. (Photograph courtesy of *We Were There . . . World War II: The Milwaukee Jewish Experience* and the Milwaukee Jewish Historical Society.)

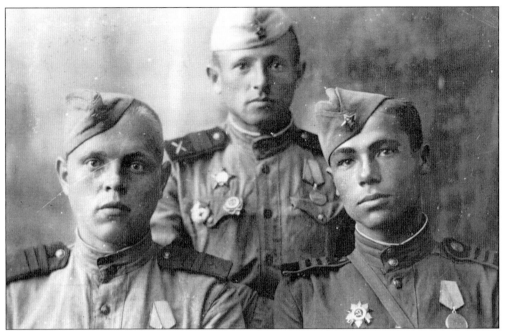

Yakov Krugly (center) was a senior sergeant in an artillery brigade attached to the Soviet Army's general headquarters. He fought in Kursk, Bielorod, and Orelin in the summer of 1943 and helped liberate Kiev. During that action, Krugly was decorated for his bravery. He emigrated to Milwaukee after the war. (Photograph courtesy of Revmir Kancvsky, *We Were There . . . World War II: The Milwaukee Jewish Experience*, and the Milwaukee Jewish Historical Society.)

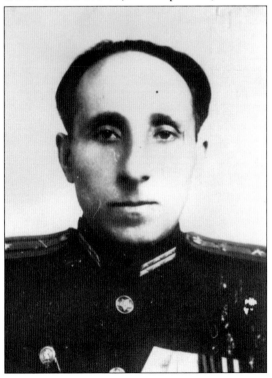

Peter Slonim came to Milwaukee several years after serving in a Soviet Army anti-aircraft unit on the Ukrainian front. He was only one of nine survivors from his 82-person unit as it battled German forces around Kursk in one of the largest clash of armored units during World War II. Slonim also fought at Kiev and Lvov. Because of his musical training, Slonim organized concerts to keep up morale. After the war, he used his talents as a stage manager and theater producer in Harkov, Ukraine. Emigrating to Milwaukee, he was an active producer even at age 89. (Photograph courtesy of *We Were There . . . World War II: The Milwaukee Jewish Experience* and the Milwaukee Jewish Historical Society.)

Seaman Second Class Neiland Cohen participated in five major invasions in the Pacific during World War II. When his ship was in port, the non-Jewish officers made arrangements for him to attend religious services in nearby Army camps. Serving from May 1944 to May 1946 he recalled his parents' concern over how he would adjust to non-Jewish food.

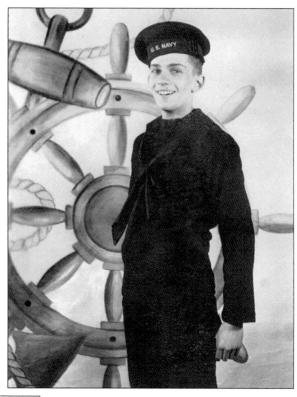

Major Arthur Post was another highly decorated Milwaukeean, receiving the Distinguished Service Cross, the Distinguished Flying Cross, two Air Medals, and two Purple Hearts. In 1943, Post was shot down in a dogfight with a Japanese fighter. His burning reconnaissance plane was unarmed so Post rammed his attacker before parachuting into the New Guinea jungles where he hid for 100 days before being rescued. Post was killed test-flying a P-38 before the war ended. At the time, he was awaiting his promotion to full colonel at age 27. (Photographs courtesy of *We Were There . . . World War II: The Milwaukee Jewish Experience* and the Milwaukee Jewish Historical Society.)

In 1996, Mayor John Norquist (center) presented a proclamation honoring Jewish war veterans to Morris Luck (left) and Leonard C. Brody. Ex-Marine Brody is currently state commander of the Jewish War Veterans (JWV) and secretary of the Milwaukee County Allied Veterans Council. Luck, who had been in the Army Air Corps during World War II, was past state and regional commander of the JWV. (Photograph courtesy of the *Wisconsin Jewish Chronicle*.)

Paul R. Fine (pointing, right), a Korean War veteran, looked over the Jewish War Veterans wall of honor. With him was Paul Weprinsky, formerly an Air Force senior master sergeant. The men studied photographs of Milwaukee service personnel of Jewish heritage killed in the line of duty. The pictures are displayed in the Milwaukee Jewish Home and Care Center. Both men are past state commanders of the Jewish War Veterans. (Photograph by author.)

Harold Keene served in the Army from 1950 to 1953 and returned to service in 1976 as a recruiter. In this 1987 photograph (top), he had just received an Outstanding Retention NCO award while with the 351st Civil Affairs Command. He retired in 1993 and joined the administrative staff at St. John's Military Academy in Delafield, Wisconsin. His son Samuel (pictured below) was an Air Force sergeant, a loadmaster with the 440th Air Lift Wing. He was killed in 1997 when his C-130 Hercules overshot a runway and crashed near Toncontin International Airport in Tegucigalpa, Honduras. Keene's other children—Lonnie, Allen, Steven, and Gail—were also in military service. (Photographs courtesy of Harold Keene.)

FOR FURTHER READING

Swichkow, Louis J. and Lloyd P. Gartner. *The History of the Jews of Milwaukee*. Philadelphia: The Jewish Publication Society of America, 1963.

Traxler, Ruth. *The Golden Land*. Milwaukee, WI: Milwaukee Jewish Council for Community Relations, 1994.

ed. *We Were There . . . World War II: The Milwaukee Jewish Experience*. Milwaukee, WI: Milwaukee Jewish Archives. 1996.

Websites:

The Milwaukee Jewish Historical Society
www.milwaukeejewishhistorical.org

Jewish American Collection of the Milwaukee Urban Archives
http://www.uwm.edu/Dept/Library/arch/jewsal.htm

Other:

The Wisconsin Small Jewish Communities History Project is a program of the Wisconsin Society for Jewish Learning. Contact the project at 5225 N. Ironwood Road, Suite 120, Glendale, WI 53217 (414-963-4135, or e-mail to wsjl@wsjl.org).

The Chudnow Museum of Yesteryear honors Jewish immigrants and their occupations. The facility is located at 839 North Eleventh St. Milwaukee, WI, (414-274-6010, ccconstr@execpc.com). The late Avrum Chudnow, president of Suburban Management Co. and international philanthropist, created his own private museum with hundreds of objects. Reservations for a tour are suggested.

Many Milwaukee synagogues also have websites.